WHAT IS A PRINT?

Selections from The Museum of Modern Art

WHAT IS A PRINT?

Selections from The Museum of Modern Art

Sarah Suzuki | The Museum of Modern Art, New York

Published by The Museum of Modern Art,
11 West 53 Street, New York, New York
10019-5497 (www.moma.org)

This publication was made possible by the
Nancy Lee and Perry Bass Publication
Endowment Fund.

Produced by the Department of Publications,
The Museum of Modern Art, New York

Edited by Kyle Bentley
Designed by Naomi Mizusaki, Supermarket
Production by Matthew Pimm
Color separations by Dr. Cantz'sche
Druckerei, Ostfildern, Germany
Printed and bound by NINO Druck GmbH,
Neustadt an der Weinstrasse, Germany

This book is typeset in Whitman and Benton
Gothic. The paper is 150gsm Profimatt.

© 2011 The Museum of Modern Art, New York

Library of Congress Control Number:
2011934424
ISBN: 978-0-87070-818-3

Front cover:
Christoph Ruckhäberle, *Untitled (Woman 4)*,
2006; see plate 33.

Back cover, clockwise from top left:
Edward Ruscha, *Standard Station*, 1966;
see plate 98. Natalia Goncharova, *Angely
i aeroplany* (Angels and airplanes), 1914;
see plate 68. Seher Shah, Untitled, 2007;
see plate 129. Shaun O'Dell, *Beyond When the
Golden Portal Can Come*, 2005; see plate 58.
James Siena, *Upside Down Devil Variation*,
2004; see plate 50. Elizabeth Catlett,
Sharecropper, 1952, published 1968–70;
see plate 17.

All of the artworks reproduced on the front and
back covers are shown there as details, but
appear in complete form in the book's plates.

Process diagrams in the section introductions
courtesy The Chopping Block, Inc., Brooklyn,
New York

Distributed in the United States and Canada
by D.A.P./Distributed Art Publishers, Inc.,
155 Sixth Avenue, 2nd floor, New York,
New York 10013
(www.artbook.com)

Distributed outside the United States
and Canada by Thames & Hudson Ltd.,
181 High Holborn, London WC1V 7QX,
United Kingdom
(www.thamesandhudson.com)

Printed in Germany

FOREWORD

Print collecting has been at the heart of The Museum of Modern Art's mission from its earliest days. In fact, the first work ever to be accessioned into the Museum's permanent collection was a printed self-portrait by Max Beckmann in 1929. Abby Aldrich Rockefeller, one of the Museum's founders and herself an avid print collector, recognized printed art's potential for accessibility and wide reach, a capacity that aligned with MoMA's aim of encouraging the appreciation of modern art among a broad audience. In 1940, Mrs. Rockefeller donated her collection of sixteen hundred prints to the Museum, a gift that today remains the core of our print collection, which now numbers well over fifty thousand and ranks among the finest of its kind in the world.

The technical fundamentals of the various printmaking methods are often elusive to museum-goers. In 2001, the Department of Prints and Illustrated Books launched an innovative website—called What Is a Print?—that sought to demystify the processes through animated demonstrations and examples from MoMA's collection. Since that time, this website (www.moma.org/whatisaprint) has remained one of our most popular subsites and has proved a valuable tool for museums and educational institutions around the world. I am delighted by the publication of this companion volume, which seeks to expand the purview of the website by tracing the histories of printmaking mediums through a much larger selection of masterworks from the Museum's collection.

Reflecting the breadth of the print department's collecting practice, the current volume follows other notable catalogues—namely Riva Castleman's *A Century of Artists Books* and Deborah Wye's *Artists & Prints: Masterworks from The Museum of Modern Art*—examining our collection through the lens of technique and with an eye toward a more global outlook. My thanks go to Sarah Suzuki and the exemplary staff of the print department for their efforts in bringing this project to fruition in such a dynamic and accessible fashion.

Glenn D. Lowry
Director, The Museum of Modern Art

ACKNOWLEDGMENTS

I have been fortunate to work with an incredibly talented and dedicated team of people on this project. First, the book would not have been possible without The Museum of Modern Art Director Glenn D. Lowry and his unflagging commitment to the researching and documenting of the Museum's collection. In the Department of Prints and Illustrated Books, my thanks go to Chief Curator Christophe Cherix for his exemplary scholarship as well as his support and enthusiasm; to Chief Curator Emerita Deborah Wye, who initiated the project and provided invaluable guidance for it; and to Associate Curator Starr Figura, whose work on the "What Is a Print?" brochure and website were foundational to this volume. Cataloguer Emily Edison and Collection Specialist Katherine Alcauskas gave the project much-appreciated support, as did Department Manager Sarah Cooper and Department Assistant Alex Diczok, who ensured that I had access to materials from all corners of the globe. I am grateful to Preparator Jeff White for his ability to keep everything running, as ever, like a finely tuned machine. Special thanks go to the following MoMA interns, who offered greatly needed assistance: Danielle Cantor and Gabrielle Messeri served as thorough researchers; Suzi Bigliani handled photography and copyright credits with speed and professionalism and manipulated Excel in ways I never thought possible; and Alexander Fang, the Louise Bourgeois Twelve-Month Intern, helped coordinate the project in its early stages and remained with me in spirit throughout. I am indebted to Associate Conservator Scott Gerson, who offered his unrivaled professional expertise on matters large and small. Outside of MoMA, Shelley Langdale, Associate Curator of Prints and Drawings at the Philadelphia Museum of Art, remains a peerless colleague, and I am immensely grateful for the careful reading and thoughtful feedback she provided under an unreasonable deadline.

I would also like to extend warm thanks to MoMA's Department of Publications. Publisher Christopher Hudson and Associate Publisher Kara Kirk were supportive from the outset. Editorial Director David Frankel provided substantial guidance as the project took shape and steered me through the labyrinthine world of caption formatting. Production Director Marc Sapir

shepherded the book through its initial phases of production with an ease matched only by Production Manager Matthew Pimm, who saw the project through to the end. The publication was also produced with the aid of colleagues outside the Museum: Naomi Mizusaki of Supermarket tackled the design with vigor and verve, while Kyle Bentley turned an often challenging editorial process into an enjoyable and productive collaboration.

Many thanks to ULAE, who generously offered their workshop resources, and to Chopping Block, whose brilliant design for the What Is a Print? website (www.moma.org/whatisaprint) helped generate the demand for this companion volume and whose terrific imagery is used as marginalia throughout it. In the Department of New Media, Allegra Burnette and Maggie Lederer coordinated with Chopping Block and patiently answered my many queries about website traffic. Nancy Adelson, in the Office of the General Counsel, offered her reliably sage advice on matters of rights and reproduction.

In Imaging Services, Erik Landsberg and Robert Kastler handled my various requests with admirable grace, and Roberto Rivera swiftly routed every issue to its appropriate party. I send my appreciation to them and to David Allison, Kelly Benjamin, Peter Butler, Robert Gerhardt, Thomas Griesel, Kate Keller, Paige Knight, Erik Landsberg, Jonathan Muzikar, Mali Olatunji, and John Wronn, who took the stunning photographs of the artworks that appear in these pages.

Finally, my deep gratitude goes to the artists who created these inspiring artworks, and in particular to those who contributed special projects to the book. Christiane Baumgartner's beautifully intricate woodcut, Julian Opie's graphically punchy image for the screenprint section, José Antonio Suárez Londoño's poetic illustration of intaglio, and Terry Winters's luscious lithograph give this volume life and testify to the singular qualities that make these mediums of such enduring appeal to artists.

Sarah Suzuki
Associate Curator, Department of Prints and Illustrated Books

INTRODUCTION

What Is a Print?

A print is a work of art that is made by transferring an image from an inked surface to a sheet of paper and that exists as one of multiple impressions, which together constitute an edition.

There you have the most boiled-down, traditional answer to the question of what, exactly, a print is. Now take that simple answer and explode it. Printmaking is in fact a vast field that offers a full palette of artistic opportunities; it is an age-old practice that continues with unrelenting vigor in the twenty-first century, hewing close to tradition while always expanding its boundaries.

The impulse behind printmaking—the desire to leave an imprint—can be traced back to handprints made on the walls of caves in the Paleolithic Era. Today, printmaking consists primarily of four families of techniques: relief processes, which include woodcut and linoleum cut; intaglio mediums like engraving, etching, and aquatint; planographic forms such as lithography; and stencil processes, most notably screenprint. The techniques each have their own history—having migrated from religious, craft, or commercial uses to artistic ones—and provided a means of producing an image in multiple copies before the advent of photography. Historically, prints have been made from a matrix. The composition would be, for instance, carved into a block of wood or a piece of linoleum, scratched into a copper plate, or produced as a stencil, and then inked and printed by hand or on a printing press. Today, however, prints are equally as likely to be made using a computer, without a physical matrix.

While printing is still most commonly done on paper, it can also be done on felt, wallpaper, concrete, and many other surfaces. Editions of twenty-five, fifty, or one hundred impressions are common. But a print can also be unique, the matrix having been inked and printed only once, or inked so that each impression offers a variation on the image. Edvard Munch often took the latter approach, investigating the ways in which changes in color affected mood and tenor.

The preceding aims to address the question of what a print is, but it is equally useful to explore *why* a print is. The particular physical and technical properties of printmaking result in unique conditions and artistic possibilities. For example, prints can document certain aspects of the creative process as no other medium can. As an artist works to create a composition, he or she can periodically ink and print the matrix in order to see just how the image will look. These intermediate impressions are known as states, and together they serve to track the evolution of a given work. At the end of the process, the artist has not only the finished product but also a paper trail chronicling the way in which the image came to be—unlike in painting or drawing, in which earlier incarnations are painted over or erased away. For some artists, such as Jasper Johns, these intermediate states have become the starting point for new compositions. And for viewers, they can function as a fascinating illustration of the artist's train of thought.

Printmaking also allows artists to distribute their work more widely than would painting or drawing, which produce single works that can be physically present in only one place at one time. Odilon Redon's printed imagery reached a vast audience, helping cement his artistic reputation during his lifetime. For José-Guadalupe Posada, prints in large editions offered a means of disseminating social and political messages to the people of Mexico. Claude Flight saw democratic possibilities in the medium of linoleum cut: aspiring artists had easy access to the materials, could quickly master the technical knowledge necessary to carry out the process, and could make images without a printing press, by just inking the matrices and pressing them by hand. For just under a decade beginning in 1935, the Federal Arts Project arm of the United States government's Works Progress Administration, created to help support working artists during the Great Depression, distributed prints for display in public buildings and offices throughout the country. And in 1990, Vienna's Museum in Progress began publishing prints in daily newspapers, generating unexpected encounters with art for tens of thousands of people.

Collaboration is at the heart of many printed projects, with the acts of drawing, cutting, and printing the matrices often carried out by different people. To work outside the solitary environment of the studio can be a fruitful experience for artists, as conversations with master printers can help them expand their skills, find unexpected avenues to the effects they seek, and spark new developments in their work. At times, as occurred for Pablo Picasso, simpatico printers become true collaborators, helping forge new ground and pushing an artistic practice into unfamiliar territory.

This volume does not offer the how-to of printmaking. (There are already numerous such guides in circulation, some of which can be found in the bibliography on page 166.) Instead, it aims to provide a starting point for understanding the nature of a print and the distinctive visual vocabulary of each medium, while also illustrating the ways in which artists have utilized the special opportunities afforded by printmaking—in terms of distribution, reproduction, and collaboration—in artistic masterpieces from the beginning of the modern period to the present day.

WOODCUT

Woodcut is among the oldest printmaking techniques. It is also the best known of the relief processes, in which an image is rendered in relief on a matrix and then inked and pressed to a sheet of paper or other support. Requiring only the most basic of means, relief prints have technical parallels throughout everyday life, from the fingerprints that smudge kitchen counters to the postage dates rubber-stamped on our mail.

In their simplest form, relief mediums require only something to cut into, something to cut with, some ink, and some paper. Wood has been the most popular material for relief matrices for hundreds of years, followed closely by linoleum, which found an ardent following in Great Britain in the 1920s, though plywood, acrylic, cardboard, metal, and even potatoes have been used as well.

The process of the modern woodcut generally begins with a block (often from a pear, sycamore, cherry, or beech tree), onto which the artist draws or sketches an image. Tools including gouges, chisels, and knives are used to cut away the wood in order to develop the composition in raised form. Once finished, the block is inked using a roller. A sheet of paper is laid on top and then rubbed with the back of a spoon or with a similar instrument, or the prepared block is run through a press, in order to transfer the inked areas to the paper. When the sheet is lifted away, the image appears printed on it in reverse. If the work calls for multiple colors, separate blocks are usually created for each one.

As with almost all the techniques discussed in this book, woodcut was not initially used for artistic purposes. It originated in ninth-century Asia as a means to communicate and disseminate Buddhist sutras, with the earliest known example being an impression of the Diamond Sutra from 868 AD (currently held in the collection of the British Library in London). Five centuries later, woodcut was likewise adopted for religious purposes in Europe, where the technique had previously been employed primarily in textile printing. The development of the European paper industry in the fourteenth century led to the production of inexpensive woodcuts of biblical scenes and saints that were sold as devotional objects and souvenirs to predominantly illiterate religious pilgrims. In the fifteenth century, woodcut was used to produce religious block books, in which text and image, having been carved together on a single matrix, appeared on the same page. Secular usage of woodcut also developed, in the printing of playing cards, for instance.

Practitioners of the medium were considered craftsmen, not artists, until the arrival of Albrecht Dürer (1471–1528). The unofficial "king" of the Northern Renaissance, Dürer is commonly credited with nearly single-handedly turning woodcut into a viable medium for artistic expression: he infused the process with a new vitality, coaxed tapering lines out of seemingly unyielding wood, and introduced a compositional dynamism in works including his famed *Four Horsemen of the Apocalypse* (c. 1496). Although Dürer was unquestionably a master of graphic techniques (his experiments with intaglio would also be significant), he did not always work alone. At times, he relied on the skills of craftsmen to help him realize his compositions in printed form.

The collaborative functionality of woodcut became more codified in eighteenth-century Edo Japan, with the development of polychrome *ukiyo-e* prints. Dubbed "pictures of the floating world," these woodcuts portrayed aspects of pleasurable life in the Japanese capital—kabuki actors, famous courtesans, views of Mount Fuji, and erotic encounters were all popular subjects. Separate blocks would be made for each of a work's various colors, and then printed one after the next, and in careful alignment, to produce the final image. Each step in this process required its own expert—an artist to create the drawing, craftsmen to cut the blocks, and master printers to align, register, and print from the blocks.

In a certain way, it is with these eighteenth-century Japanese pictures that the arc of the story in the plates that follows begins. Woodcut returned to the artistic fore in late-nineteenth-century France, hot on the heels of an influx of Japanese *ukiyo-e* prints. The prints initially played a modest role in France; they were used to wrap imported objects. In 1890, however, the École des Beaux-Arts in Paris held an exhibition of over seven hundred *ukiyo-e* works, after which myriad artists including Vincent van Gogh and Paul Gauguin began collecting them. Characteristics of these pictures—for example, their multiple colors, bird's-eye views, flattened perspectives, and decorative patterning—began seeping into the work of European artists.

Ukiyo-e prints were appealing not only for their stylistic qualities but also for the foreign life they portrayed, particularly to artists like Gauguin, who was perpetually in pursuit of the exotic. Seeking to throw off the shackles of his bourgeois family and banker training, Gauguin decamped in 1891 to Tahiti, where he hoped to find a way of life less restrained by European social mores and more in tune with nature and free love. When Gauguin returned to Paris after this first sojourn, he began working on *Noa Noa* (Fragrance, 1893–94; pls. 1–2), an autobiographical text about his Tahitian experience. The ten accompanying woodcuts depict island life through a lens of observed reality, myth, and fantasy, often featuring large, flat, shadowless planes that he borrowed from *ukiyo-e* images and often containing—due to his purposefully off-register printings—an air of mystery.

The influence of the East has carried through in Western printmaking in the ensuing years. In 1915, a group of printmakers in Provincetown, Massachusetts, pioneered a method they called white-line woodcut, which was inspired by multicolor *ukiyo-e* printing but required only a single block and which is still in use today. And in the 1980s, San Francisco's Crown Point Press undertook a project introducing contemporary artists in the West to *ukiyo-e*. Drawings were submitted and then sent to Kyoto, where they were transferred to blocks, carved, and printed by master artisans in the Japanese tradition. One of these projects was Helen Frankenthaler's *Cedar Hill* (1983; pl. 24), consisting of thirteen blocks, five of which Frankenthaler ended up carving herself in an effort to find satisfaction with the image.

Woodcut is often described in terms of gouging, slashing, and chiseling, and there is indeed an inherent physicality to the process that often translates to the finished work. Vasily Kandinsky described the process of making a woodcut dot by saying: "in order that the point may enter the world (like a fortress with a ditch) it is necessary to do violence to its entire surroundings; to tear out and destroy them."[1] Kandinsky and his fellow German Expressionists in the 1910s and 1920s, including Erich Heckel and Emil Nolde, dove into

woodcut with relish, gouging from the block and using splintery, agitated lines to convey desire for the primal, the exotic, the archaic.

Fifty years later, Germany saw a resurgence of interest in woodcuts and linoleum cuts among neo-Expressionist artists. Chief among them was Georg Baselitz, who became deeply involved with print mediums as both a practitioner and a collector. In an untitled print from 1967 (pl. 22), he looked back to woodcut's history, emulating the style of sixteenth-century chiaroscuro woodcuts, as well as Mannerist musculature, through a blocky figure-type he called "the hero."

German artists of a subsequent generation, including Christiane Baumgartner and Christoph Ruckhäberle, have also become devotees of relief mediums. In *Untitled (Woman 4)* (2006; pl. 33), Ruckhäberle refers to the legacy of the *Brücke* (Bridge) artists—who exploited the medium's potential for graphic simplicity and bold, flat coloring—with an image clearly reminiscent of Erich Heckel's *Fränzi liegend* (Fränzi reclining, 1910; pl. 8).

While relief mediums, with their emotive possibilities, seem particularly suited to expressionistic works, they have also been used to great effect in conceptual projects. Sherrie Levine, who often questions ideas of authenticity and originality by appropriating work by modern masters, took up woodcut for her 1989 portfolio *Meltdown* (pl. 26). For each of the four prints, Levine used a computer to reduce a painting by Claude Monet, Ernst Ludwig Kirchner, Piet Mondrian, or Marcel Duchamp to twelve colors, which she then rendered in grid form. Driven not by gouge or chisel but rather by a sophisticated idea, Levine circumvented traditional approaches to woodcut, bringing an ancient technique into the digital age.

1. Vasily Kandinsky, *Point and Line to Plane*, trans. Howard Dearstyne and Hilla Rebay (New York: Solomon R. Guggenheim Museum Foundation, 1947), p. 49.

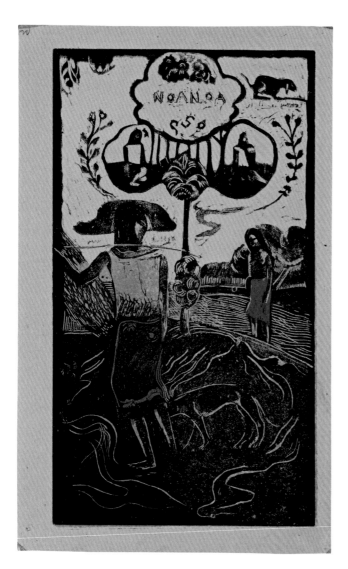

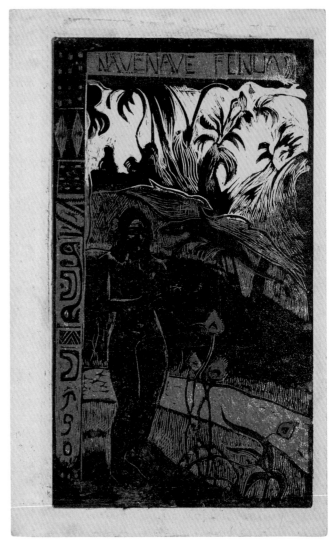

1–2 **PAUL GAUGUIN**

Noa Noa (Fragrance) and _Nave Nave Fenua_ (Fragrant isle) from the series _Noa Noa_ (Fragrance). 1893–94. Woodcuts, sheet: 15 ½ x 9 ⅝" (39.3 x 24.4 cm) and 15 ¹¹⁄₁₆ x 9 ¹³⁄₁₆" (39.9 x 24.9 cm)

3 **EDVARD MUNCH**

Kyss IV (Kiss IV). 1897–1902. Woodcut, sheet: 24 x 23 ⅝" (61 x 60 cm)

An iconoclastic printmaker, Munch cast aside traditional practices: he preferred variant printings to standardized editions, and would often saw his woodblocks into pieces so that he could ink the components in different colors, after which he would reassemble them for printing. Munch drew on his experiences of loss, loneliness, jealousy, anxiety, and desire in his work. Here, having stamped the sheet with an uncut plank to create a woodgrain backdrop, he produced an image of two entwined lovers.

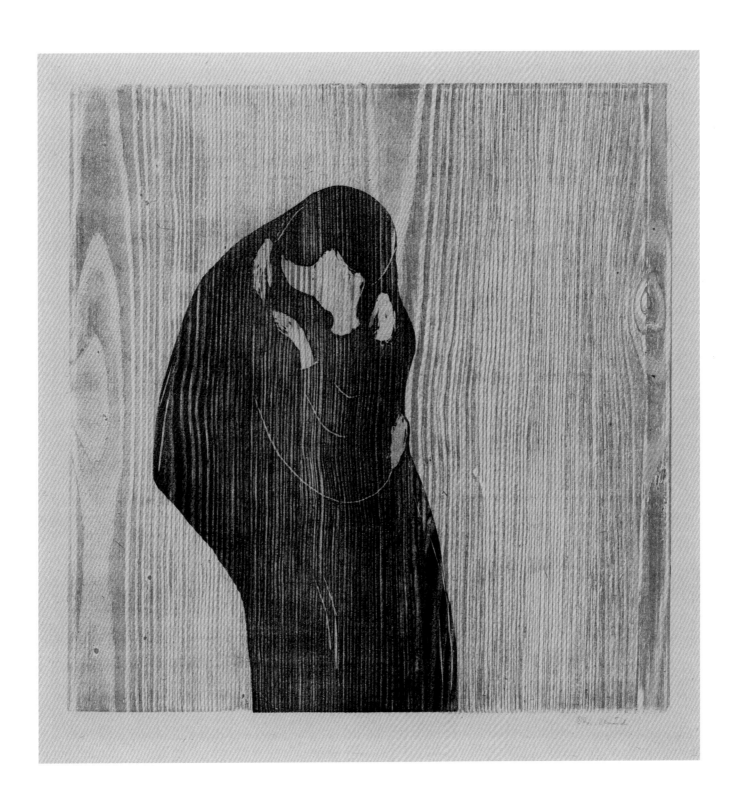

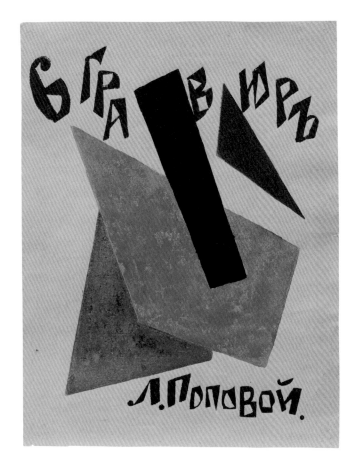 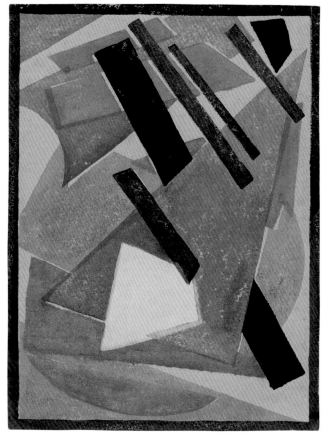

4–7 **LYUBOV POPOVA**

Untitled, Untitled, Untitled, and Untitled from the portfolio *Six Prints*. c. 1917–19. Linoleum cuts with watercolor and gouache additions, sheet (each): 15 ¼ x 11 ¹³⁄₁₆" (38.8 x 30 cm)

Popova was among the Russian avant-garde's most important figures. Inspired equally by French Cubism, Kazimir Malevich's abstract Suprematism, Vladimir Tatlin's theories of Constructivism, and Russian folk art, Popova produced distinctive architectonic compo-

sitions in a range of mediums, from painting and works on paper to theater design and textiles. In fact, her use of relief techniques in *Six Prints* may have been influenced by her experience with textiles, which at the time were often printed by woodblock.

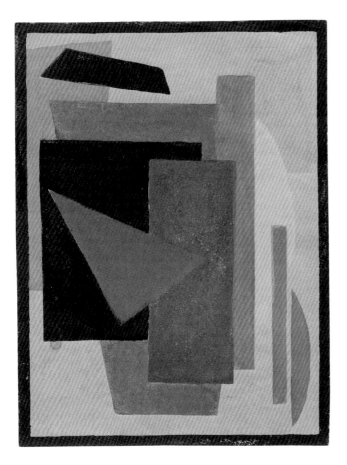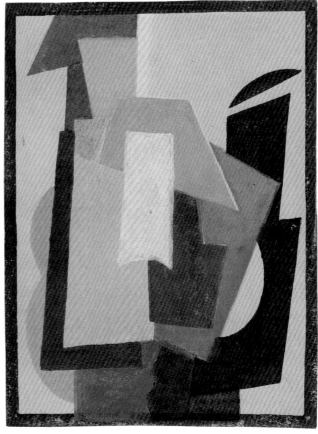

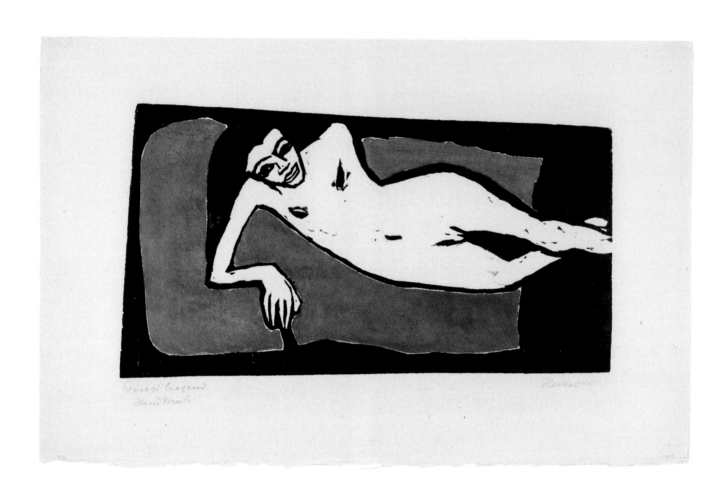

8 ERICH HECKEL

Fränzi liegend (Fränzi reclining). 1910.
Woodcut, sheet: 14 x 21 ⅞" (35.6 x 55.5 cm)

9 EMIL NOLDE

Prophet. 1912. Woodcut, composition:
12 ⅝ x 8 ¾" (32.1 x 22.2 cm)

Although Nolde spent only a year as an official member of the German Expressionist group *Brücke* (Bridge), his *Prophet* is emblematic of the appeal of woodcut to those artists. Exploiting the medium's unique suitability for rough gouging, Nolde created an image of great immediacy and iconic power that seems to have emerged from the woodblock with only a handful of digs of his knife.

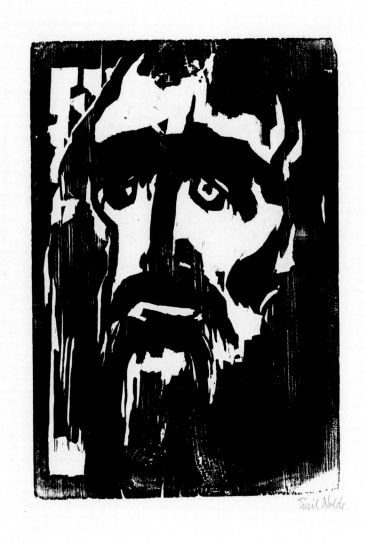

Prophet

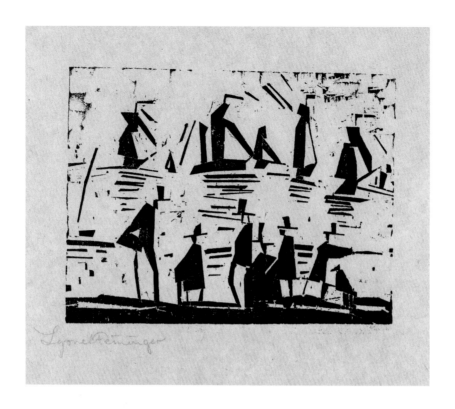

¹⁰ LYONEL FEININGER

Fischerboote (Fishing boats). 1918. Woodcut, composition: 4 ¹⁵⁄₁₆ x 6 ½" (12.6 x 16.5 cm)

Woodblock for *Fischerboote* (Fishing boats). 1918. 4 ⅞ x 6 ⅜ x ⅜" (12.4 x 16.2 x 0.9 cm)

Feininger had a successful career as a professional cartoonist before turning to fine art full-time after about 1908. His frequent subjects include village and city scenes, landscapes, and life on and near the sea. Here, the juxtaposition of a woodblock by Feininger and the resulting print helps illustrate the

relief process in general. Feininger cut away the block wherever he meant blank areas to appear in the print, as evidenced by the still-visible knife marks. The raised portion was then inked—the black liquid staining the wood—and pressed with the sheet of paper, on which the image appears in reverse.

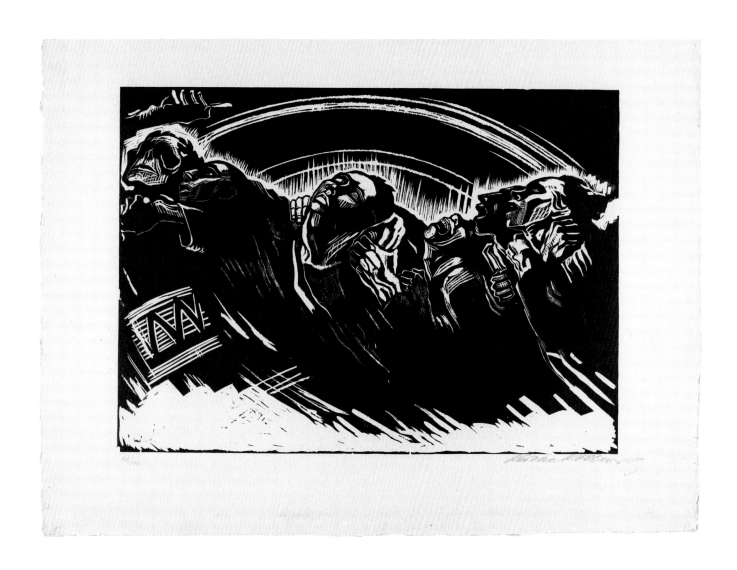

[11] **KÄTHE KOLLWITZ**

Die Freiwilligen (The volunteers) from the
portfolio *Krieg* (War). 1921–22, published
1923. Woodcut, sheet: 18 11/16 x 25 ¾"
(47.5 x 65.4 cm)

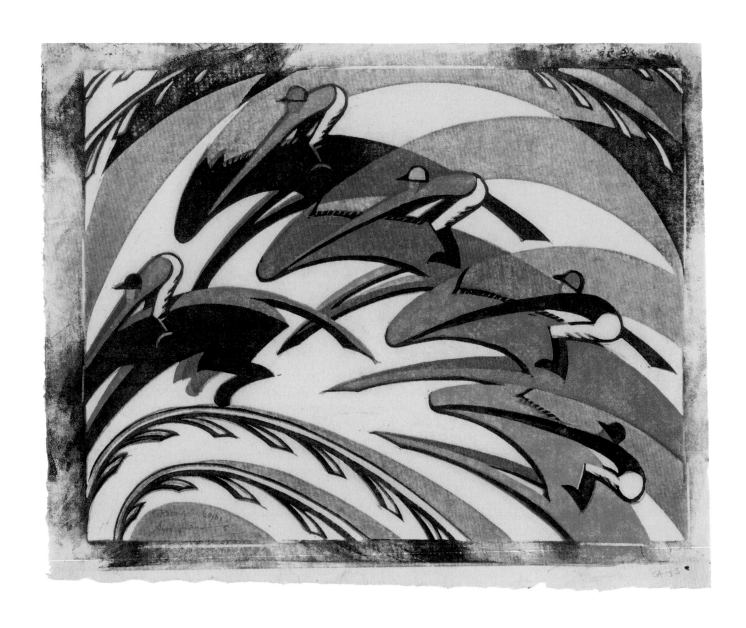

¹² SYBIL ANDREWS

Racing. 1934. Linoleum cut, sheet:
11 ⅞ x 14 ¹⁵⁄₁₆" (30.2 x 37.9 cm)

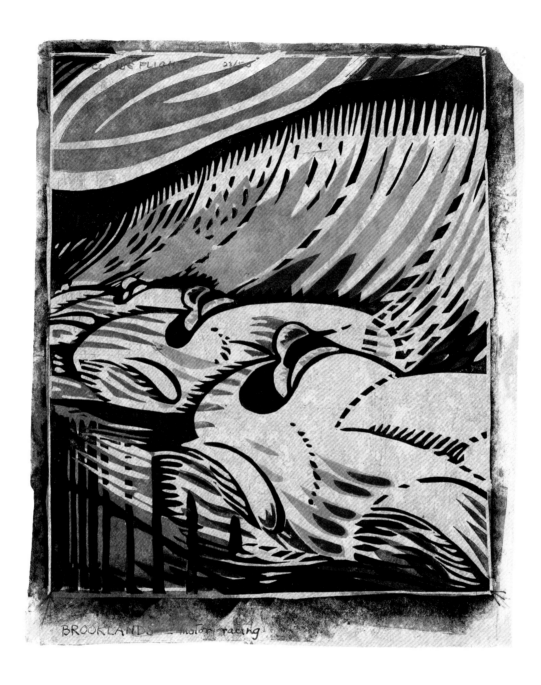

¹³ CLAUDE FLIGHT

Brooklands. c. 1929. Linoleum cut, sheet:
13 ⁷⁄₁₆ x 11 ¼" (34.2 x 28.5 cm)

One of the pioneers of linoleum cut during
the interwar period in Britain, Flight believed
in the medium's potential to be a truly
accessible art form: the materials and tools
necessary were inexpensive and readily

available, and impressions could be pulled
without a printing press or other special
equipment. Many of the linoleum cuts of
this period were influenced by the Italian
Futurists' glorification of the machine age
and the British Vorticists' abstraction of
modern life. The subjects portrayed in such
prints include the morning rush at a tube
stop, the laying of cable and power lines,

and contemporary amusements like car
racing, as seen in Flight's *Brooklands*.

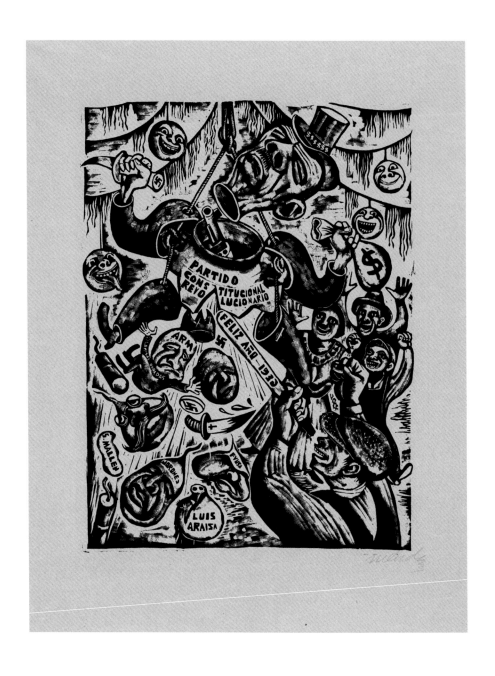

¹⁴ **LEOPOLDO MÉNDEZ**

La Piñata Política (Political piñata). 1935.
Linoleum cut, composition: 11 ⁷⁄₁₆ x 8 ¾"
(29 x 22.3 cm)

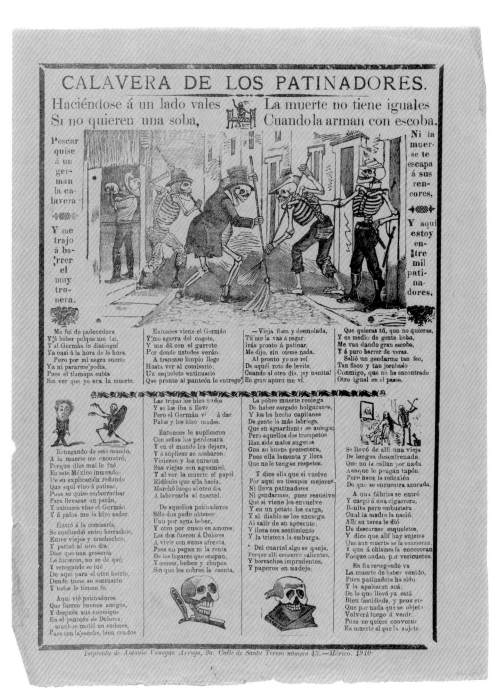

Imprenta de Antonio Vanegas Arroyo, 2a. Calle de Santa Teresa número 43.—México. 1910.

<u>15</u> **JOSÉ-GUADALUPE POSADA**

Calavera de los Patinadores (Calavera of the street-cleaners). 1910. Type-metal engraving, relief printed, and letterpress, sheet: 15 ¹¹⁄₁₆ x 11 ⅞" (39.9 x 30.1 cm)

Posada utilized printmaking's potential as a vehicle for social and political messages. He made well over a thousand prints that chronicled current events, satirized salacious news items, addressed religious or moral issues, offered short plays or ballads, and incorporated his famed *calaveras* (skulls). Intended for mass distribution, these prints were often issued as broadsides, chapbooks, posters, and "penny prints," available at very low cost. When working with relief printing, Posada preferred using zinc plates over woodblocks.

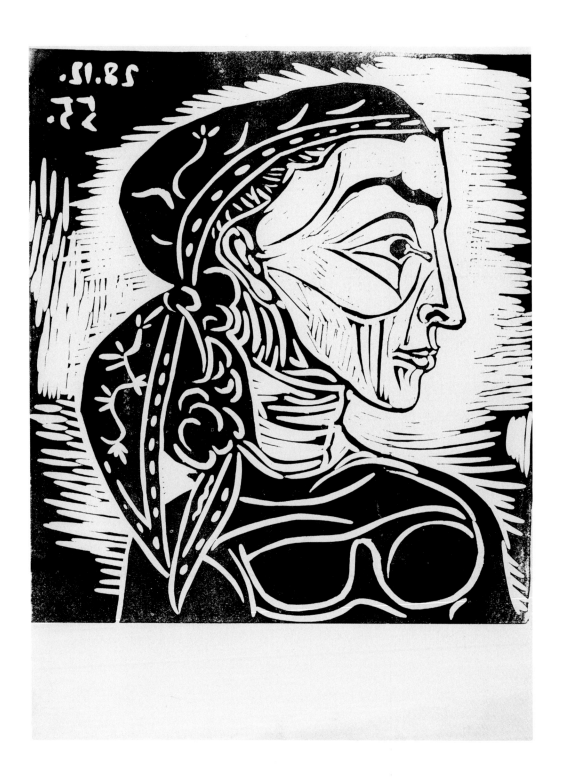

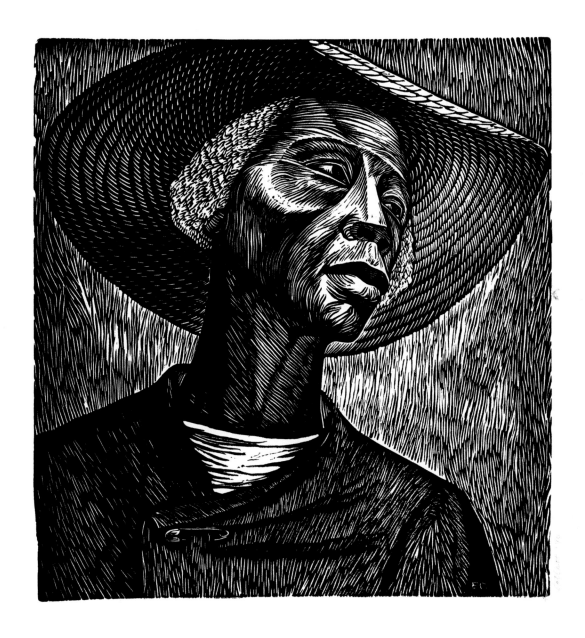

¹⁶ PABLO PICASSO

Profil de Jacqueline au foulard (Profile of Jacqueline with a scarf). 1955. Linoleum cut, sheet: 26 ⅜ x 19 ¾" (67 x 50.2 cm)

¹⁷ ELIZABETH CATLETT

Sharecropper. 1952, published 1968–70. Linoleum cut, sheet: 18 ½ x 18 ¹⁵⁄₁₆" (47 x 48.1 cm)

Cut just several years apart, these portraits harness linoleum cut's graphic power. Picasso's depicts his second wife and muse, Jacqueline Roque, while Catlett's portrays an anonymous sharecropper and champions the strength and dignity of working people. Catlett learned the medium at El Taller de Gráfica Popular, a workshop in Mexico City that sought to continue Mexico's strong historical tradition of socially and politically engaged printmaking, as embodied in the work of, among others, Leopoldo Méndez (pl. 14) and José-Guadalupe Posada (pl. 15).

¹⁸ JOSEF ALBERS

Tlaloc. 1944. Woodcut, sheet: 13 ⅞ x 13 ⅝"
(35.3 x 34.6 cm)

Tlaloc is one of a series of woodcuts Albers
made while teaching at Black Mountain
College, an experimental institution in
Asheville, North Carolina. The print is
named for a Mexican rain god, and serves

as an attempt at material transmogrification:
Albers sought to transform the grain of the
wood so that it resembled the surface of a
body of water. The artist said of the work:
"To show wood merely as wood is a factual
report. To make wood acting as water is an
actual engagement."

¹⁹ LYGIA PAPE

Untitled. 1959. Woodcut, sheet: 19 ½ x
19 ½" (49.5 x 49.5 cm)

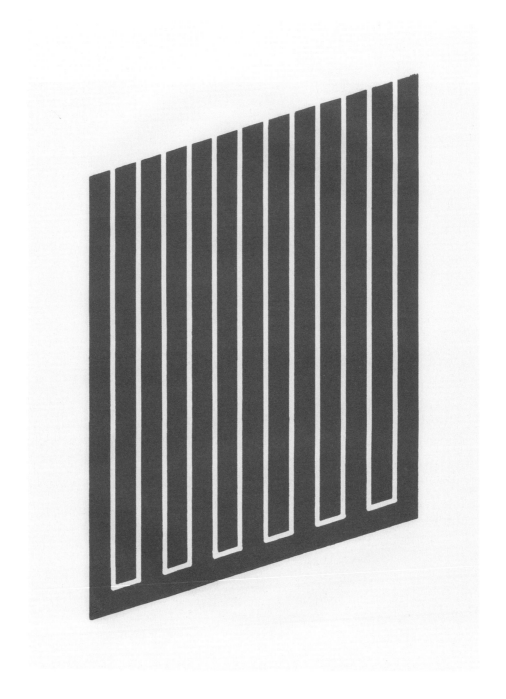

20–21 DONALD JUDD

Untitled (7-L) from the series Untitled. 1968–69 (series begun in 1963). Woodcut, sheet: 30 ⅝ x 22" (77.8 x 55.9 cm)

Untitled (7-L). 1968. Painted woodblock, 25 ¹¹⁄₁₆ x 15 ⅞ x 1 ¹⁵⁄₁₆" (65.2 x 40.3 x 4.9 cm)

Seriality was at the heart of Judd's print-making and sculpture. In the early 1960s, he began a series of twenty-six woodcuts depicting parallelograms in which small but definite variations encourage close examination by the viewer. Judd exhibited not only the prints but also the woodblocks from which they were printed, considering them to be original sculpture.

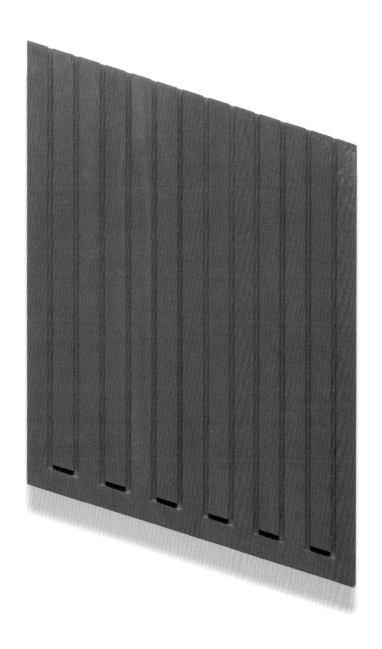

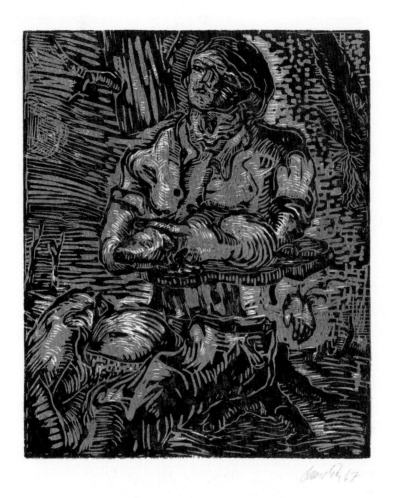

22 GEORG BASELITZ

Untitled. 1967. Woodcut, sheet: 16 ¹⁄₁₆ x 12 ¹⁵⁄₁₆" (40.8 x 32.8 cm)

23 CHARLES WHITE

Solid as a Rock (My God is Rock). 1958. Linoleum cut, sheet: 41 ⅛ x 17 ¹³⁄₁₆" (104.5 x 45.2 cm)

After being discharged from the Army in 1944, White spent two years in Mexico with his then-wife, Elizabeth Catlett (pl. 17). He studied at El Taller de Gráfica Popular in Mexico City, which championed linoleum cut for its democratic properties: the medium was relatively easy to learn and execute, didn't require expensive materials, and could withstand the production of a large edition. White was particularly moved by the work of Leopoldo Méndez (pl. 14), and himself became skilled at linoleum cut, with works like this one displaying a sculptural solidity and compositional dynamism due to the artist's vibrant linework.

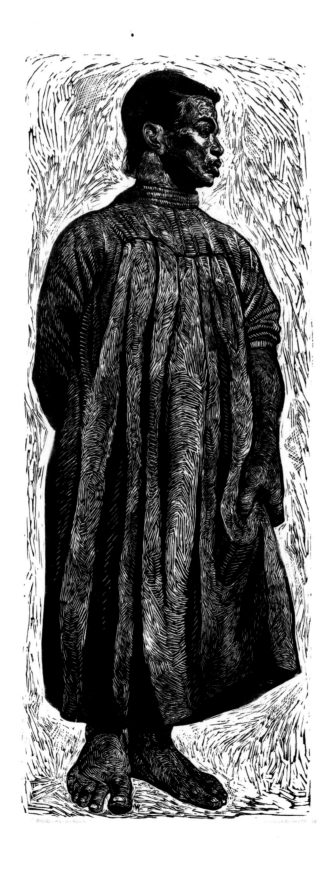

24**HELEN FRANKENTHALER**

Cedar Hill. 1983. Woodcut, sheet: 20 ⁷/₁₆ x
25 ⅛" (51.9 x 63.8 cm)

25 XU BING

Yi-yun (Moving cloud) from Series of Repetitions. 1987. Woodcut, sheet: 26 x 35 ¹³⁄₁₆" (66 x 91 cm)

Xu studied the centuries-old tradition of printmaking in Beijing in the late 1970s and early 1980s, but soon began to advance a more conceptual use of the medium, often in projects examining issues of landscape, language, and communication. In his Series of Repetitions, he abandoned planned compositions in favor of improvised, imagined landscapes. Based on memories of his years of reeducation in China's countryside during the Cultural Revolution, these prints feature recurring marks that sometimes suggest Chinese characters, anticipating his later work with language.

²⁶ SHERRIE LEVINE

Clockwise from top left: *After Duchamp*, *After Monet*, *After Mondrian*, and *After Kirchner* from the portfolio *Meltdown*. 1989. Woodcuts, sheet (each): 36 ¾ x 25 ¾" (93 x 65.4 cm)

In *Meltdown*, Levine took a conceptual approach toward traditional woodcut, combining the process with digital technology. Each grid represents in twelve pixel-like squares a chromatic reduction, determined by computer, of a painting by the given artist. Whereas a multicolor woodcut would normally require multiple passes through the press, Levine and her collaborators devised a framework that would hold all twelve blocks together and allow them to be printed in a single pass without risking registration problems that would compromise the integrity of the grid.

²⁷ ZARINA HASHMI

Home Is a Foreign Place. 1999. Woodcuts and letterpress, mounted on paper, sheet (each): 16 x 13" (40.7 x 33 cm)

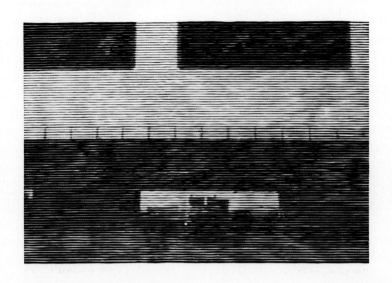

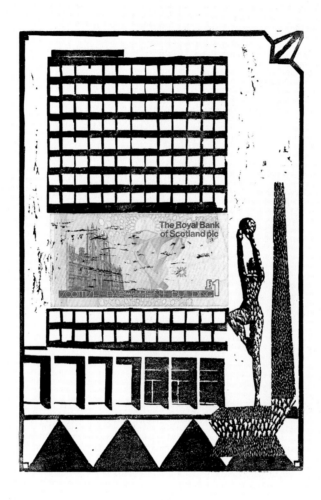

28–29 CHRISTIANE BAUMGARTNER

Schkeuditz II and *Schkeuditz IV* from the series Schkeuditz I–IV. 2005. Woodcuts, sheet (each): 23 7/16 x 30 11/16" (59.5 x 78 cm)

Baumgartner employs old mediums (like woodcut, which has a particularly strong tradition in her hometown of Leipzig) and new ones (like video) to create works that often examine the movement of objects through space and time. She uses only horizontal lines in her woodcuts, producing an optical effect not unlike that of an old untuned television set. The works illustrated here are based on video footage she took from a moving car in the German city of Schkeuditz.

30 LUCY McKENZIE

Aesthetic Integration Scotland. 2001. Linoleum cut with banknote collage addition, sheet: 16 9/16 x 11 11/16" (42 x 29.7 cm)

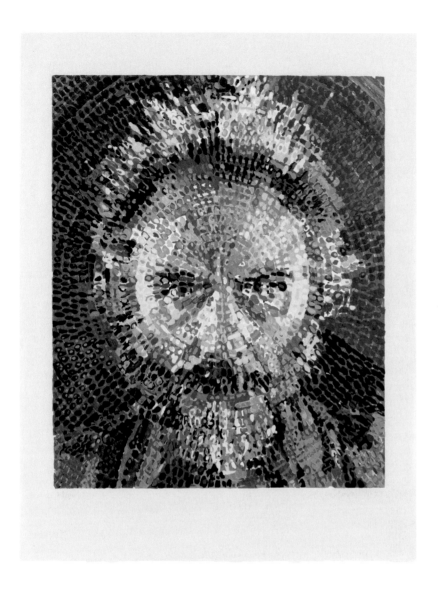

31 CHUCK CLOSE

Lucas/Woodcut. 1993. Woodcut and pochoir, sheet: 46 ¼ x 36" (117.5 x 91.4 cm)

32 GERT & UWE TOBIAS

Untitled (figure). 2005. Woodcut, sheet: 78 ¾ x 64 ¹⁵/₁₆" (200 x 164.9 cm)

Brothers and artistic collaborators Gert and Uwe Tobias produce large-scale woodcuts as the core of their practice. Drawing on modernism and art history, folk art and folklore, and the cultural identity of their native Romania, the artists create images that evoke the rough-hewn look of traditional Eastern European *lubki*, or popular prints. The Tobiases generally eschew the carving of woodblocks. Instead, they cut shapes out of plywood and use them in a stamplike fashion that recalls the experimental techniques of Edvard Munch (pl. 3), with whom they also share a rejection of standard editions, as they make only two or three examples of each print.

33 CHRISTOPH RUCKHÄBERLE

Untitled (Woman 4). 2006. Linoleum cut on three sheets, sheet (each): 39 ⅜ x 26 ¾" (100 x 67.9 cm)

This work engages with Germany's long printmaking history, referring, for instance, to the compressed interiors of Max Beckmann and the youthful bohemians and reclining models of *Brücke*. Ruckhäberle exploits the graphic potential of relief mediums by creating strong, clashing patterns, such as the stripes of the subject's dress, hair, and socks and the diamond motif on the floor.

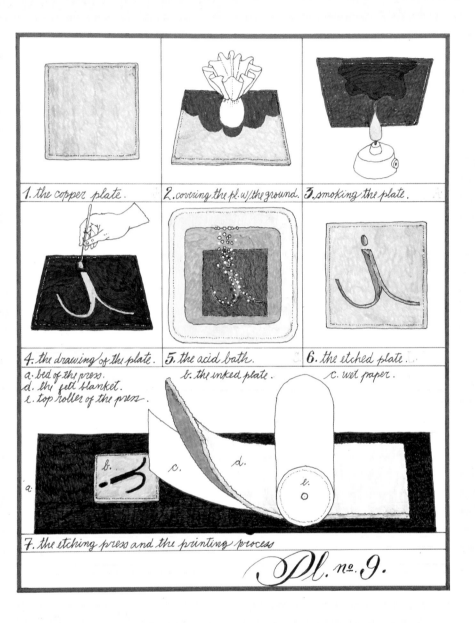

1. the copper plate.

2. covering the pl. w/the ground.

3. smoking the plate.

4. the drawing of the plate.

5. the acid bath.

6. the etched plate.

a. bed of the press.
d. the felt blanket.
e. top roller of the press.

b. the inked plate.

c. wet paper.

7. the etching press and the printing process

Pl. nº. 9.

INTAGLIO

Intaglio comes from the Italian verb *intagliare*, meaning "to carve," and is an umbrella term for a range of techniques—including engraving, etching, drypoint, aquatint, mezzotint, sugar lift, soft ground, and spit bite—that share the same basic premise. Whereas in relief printing the composition is rendered as a raised portion of the matrix, with intaglio techniques it is inscribed as a system of grooves for the ink to fill.

In some intaglio mediums, like engraving, the metal plate is carved directly by the artist with a tool called a burin, while in others, like etching, it is incised by chemicals. For the latter variety, a waxy "ground" is applied to the plate and allowed to dry. Next, the artist draws a composition into this thin coating with an etching needle, exposing the metal underneath. The plate is then submerged in an acid bath. The acid eats into the exposed parts of the metal, incising or "biting" the lines into the plate, while the acid-resistant ground protects the surrounding areas. When the incisions are sufficiently deep, the plate is pulled from the bath and the ground is removed with a solvent. The entire plate is inked—the ink often worked into the etched lines using a tool called a dabber—and then the surface is wiped clean, though the grooves remain filled with ink. The prepared plate is laid face up on the bed of a press, topped with a sheet of dampened paper and a blanket for padding, and run through the machine—the pressure of which causes the paper to pick up the ink from the etched channels.

Intaglio, like woodcut, can be said to have nonartistic beginnings. As legend has it, engraving—the first intaglio method to be developed—was discovered by accident. A goldsmith in fifteenth-century Europe had inlaid a carved plate with a black substance called niello, and left it to dry overnight with a piece of paper and a bundle of wet clothing resting on top. The next day, he found that the clothing had pushed the paper into the grooves, creating a print.

Intaglio marched forward on twin paths of the religious and the secular before being co-opted for artistic purposes. Goldsmiths, armorers, and other craftsmen were among the first to take up the new technique, using it as a means of recording and documenting the designs they were inscribing on helmets and breastplates. The engravings of German artist Martin Schongauer (c. 1448–1491), the son of a goldsmith, were tremendously influential for Albrecht Dürer, the world's first great printmaker, whose father was also a goldsmith and perhaps offered him technical instruction. Dürer went on to radically expand not only what could be done with intaglio but also how

people thought about it: he championed the prints as an art form and, in biblical, mythological, and allegorical images, bridged the styles of the Northern Gothic and the Italian Renaissance.

Etching developed from engraving in the fifteenth century, and two hundred years later Rembrandt van Rijn showed himself to be the most ambitious practitioner of the medium yet (and he remains arguably the most talented etcher in history). Rembrandt experimented relentlessly with different inks, papers, and durations for the acid bath. He often combined techniques, layering drypoint lines—which are scratched with a needle directly into the plate, producing rough metal burrs that create an inky, velvety appearance when printed—on top of etched or engraved areas in order to give his works additional depth and richness. Exploiting printmaking's capacity to document the creative process, Rembrandt printed multiple intermediate impressions as he developed a given composition. The seventeenth-century Dutch art market was enthralled by his etchings, with one of his largest and most sought-after compositions being dubbed "the hundred guilder print" for the impressive price it fetched.

Spanish artist Francisco Goya (1746–1828) was an early champion of aquatint—an intaglio medium in which a fine powdered resin is applied to the plate, resulting in areas that, when bitten by acid, develop a pitted texture that produces tone rather than line in the print. In his series *Los Caprichos* (1797–98), which satirizes a range of subjects from politics to widely held superstitions, and *Disasters of War* (1810–20), which documents the horror, degradation, humiliations, and atrocities of war, he relied heavily and sometimes exclusively on the smoky values of aquatint grays, giving the images an ominous sense of space and volume.

Artistic intaglio practices continued unabated in Europe in the nineteenth and twentieth centuries. Belgian artist James Ensor (1860–1949) made over 140 prints, working in the attic of his family's souvenir shop in the beach town of Ostend. Many of these images reflect his personal preoccupations—death, politics, current events, and religion—through a filter of fantasy and

the grotesque. *Les Gendarmes* (1888; pl. 35) offers a pointed response to the true story of two fishermen killed by the military during a worker's uprising. In Ensor's depiction, the gendarmes preside over a bier with the corpses, while the riot in the street is seen through an open doorway. The wavering lines give the image an almost dreamlike appearance. Intaglio lends itself to such idiosyncratic or visionary works, perhaps in part because of the intimacy of the process: the plates are often as small as a notebook page, and scratching into them can have a meditative effect.

In the United States, there was a less sustained interest in artistic intaglio practices. During the New Deal era, however, the Works Progress Administration commissioned artists to create works including murals, posters, and prints as a means of both supporting the arts and alleviating the rampant unemployment of the Great Depression, sparking a surge of intaglio and other printmaking techniques. Stanley William Hayter, a British research chemist, created a center for intaglio practices in New York when he relocated Atelier 17, his etching workshop, from Paris following the outbreak of World War II. Against the backdrop of Hayter's intaglio laboratory, European exiles including Marc Chagall and Surrealists André Masson and Joan Miró mingled with younger American artists such as Jackson Pollock and Louise Bourgeois. The workshop became the epicenter of intaglio printmaking in the United States.

Intaglio mediums can be particularly appealing to obsessive mark-makers, as they facilitate the creation of tight grids and dense areas of parallel, looping, or hatched lines. For the Japanese artist Yayoi Kusama, childhood visions of a universe covered in dots or nets were the origin of an artistic vocabulary that she has mined throughout her career using repeating forms. An example of this is *Endless* (1953–84; pl. 46), one work of many from a long period in which she explored the motif of a seemingly infinitely looping line punctuated by dots.

Kiki Smith is one of the most accomplished printmakers in recent decades, and her *White Mammals* (1998; pl. 51) demonstrates—in the pelts of the seven carcasses—her attraction to and aptitude for the repetitive

scratching and fine linework of etching. James Siena, Smith's contemporary, builds up images of complicated networks—mazes, maps, and nested forms. *Upside Down Devil Variation* (2004; pl. 50), with its clarity of line, speaks to Siena's mastery of engraving. Suggesting topographical or celestial forms, the radiating bursts have a shimmering, nearly hallucinatory quality.

Among a younger generation of artists, Ernesto Caivano (b. 1972) has exploited intaglio to further an epic narrative of his own devising, complete with its own cosmology, mythology, and cast of characters. In the portfolio *Knight Interlude* (2005; pls. 52–53), he depicts a knight who, over the course of one thousand years, becomes a tree. In this imaginative tour-de-force, Caivano mines the history of intaglio—evoking Goya's veritable rainbow of aquatint grays, for example—as well the unique properties of printmaking, tracking the knight's conversion in twelve progressive states that themselves evidence a process of transformation.

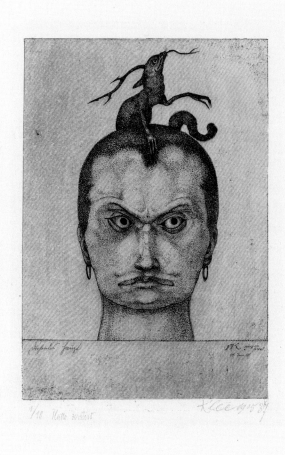

34 PAUL KLEE

Drohendes Haupt (Menacing head) from the series *Inventionen* (Inventions). 1905. Etching, plate: 7 ¹¹⁄₁₆ x 5 ¾" (19.6 x 14.6 cm)

As a young artist, Klee found himself frustrated with painting, and so he turned to printmaking. Between 1903 and 1905, he made *Inventionen*, a series of twelve

etchings featuring images from his own imagination, namely humans, birds, and hybrid creatures with strangely attenuated and muscled bodies. Klee wrote in his diaries that *Drohendes Haupt* would be the last work in this series and that he would next look for inspiration in Spain, "where Goyas grow."

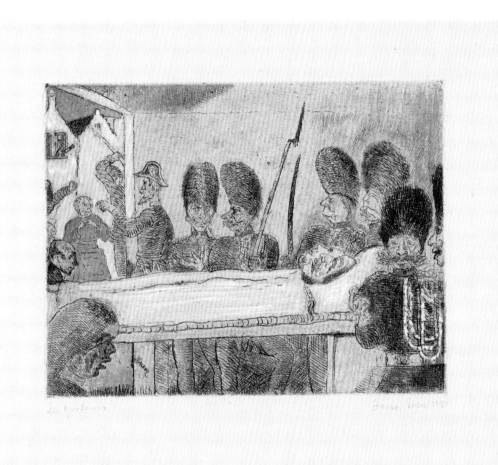

35 **JAMES ENSOR**

Les Gendarmes, state VI. 1888. Etching
with gouache additions, plate: 7 x 9 ⅜"
(17.8 x 23.8 cm)

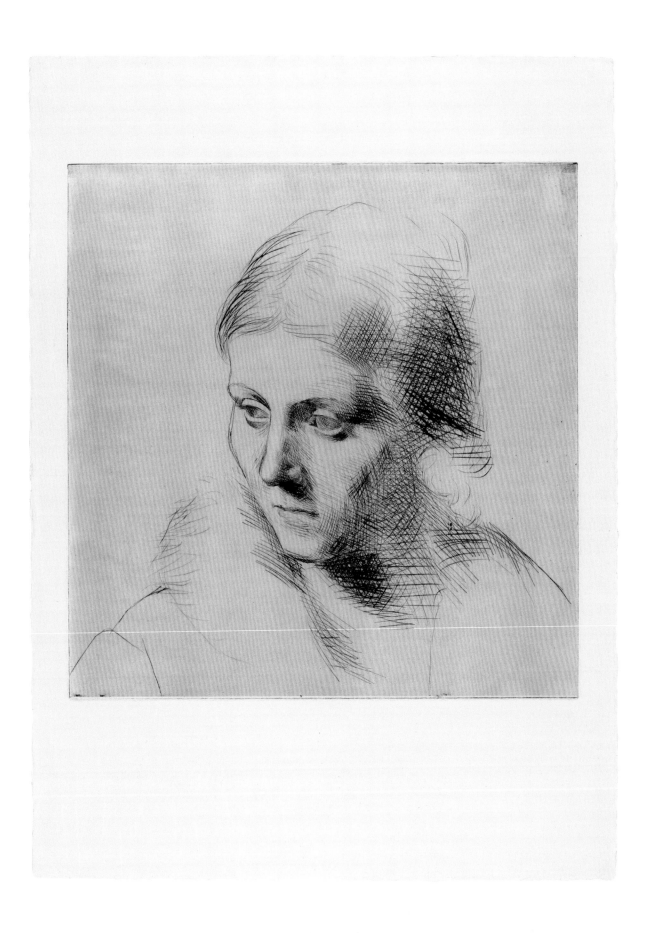

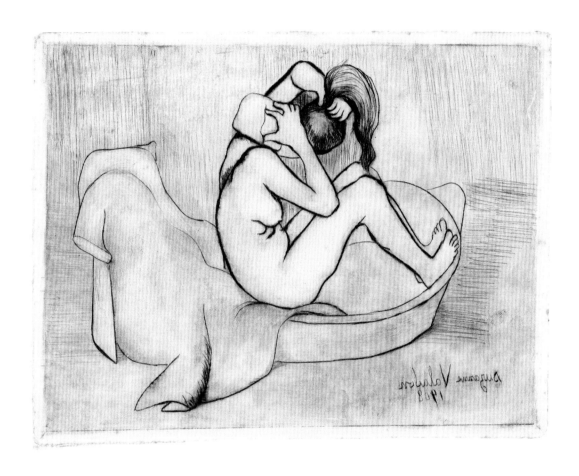

³⁶ PABLO PICASSO

Portrait d'Olga au col de fourrure (Portrait of Olga in a fur collar). 1923, printed 1955. Drypoint, sheet: 30 1/16 x 22 1/4" (76.3 x 56.5 cm)

Olga Kokhlova, a Russian ballet dancer, was Picasso's first wife, and although she was the muse of his so-called Neoclassical period, there are only several prints of her. In this large drypoint, Picasso captured her with the intimacy of a sketch. He used drypoint's feathery line quality, enhanced by the burr of the incised marks on the plate, to loosely suggest the texture of her fur collar. He also allowed some ink to remain on the matrix's surface when printing, giving the composition a rich plate tone and an undercurrent of melancholy that perhaps reflected their deteriorating relationship.

³⁷ SUZANNE VALADON

Marie au tub s'epongant (Marie bathing with a sponge). 1908. Drypoint, sheet: 6 11/16 x 8 3/4" (17 x 22.1 cm)

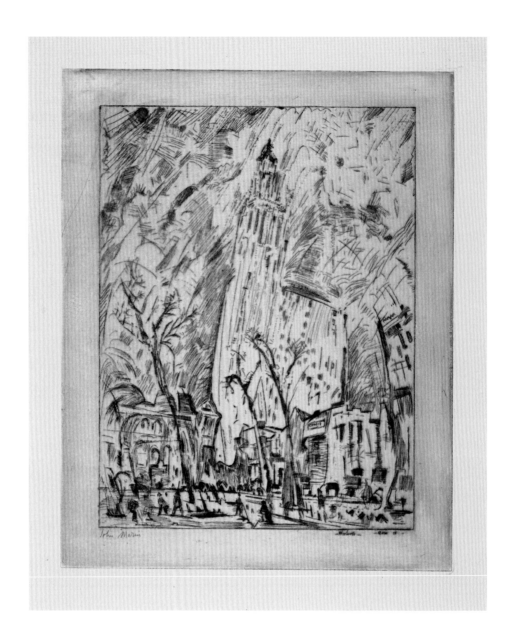

38 **JOHN MARIN**

Woolworth Building (The Dance). 1913.
Etching, plate: 13 1/16 x 10 5/8" (33.2 x 27 cm)

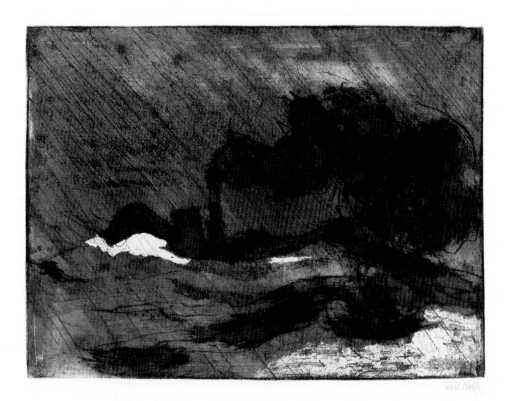

39 EMIL NOLDE

Dampfer (gr. dkl.) (Steamer [large, dark]).
1910. Etching, plate: 11 ⅞ x 15 ⅞" (30.2 x
40.4 cm)

While staying at a rooming house in Hamburg
in early 1910, Nolde made a group of works,
including nineteen etchings and four wood-
cuts, that depict scenes of the city's bustling
harbor from different vantage points, at
different times of day, and under various
atmospheric conditions. In this print, a
fishing steamer is nearly obscured by the
roiling waves, driving rain, and plume of
dark smoke. Nolde gradually built up layers
of line and tone to create the composition.

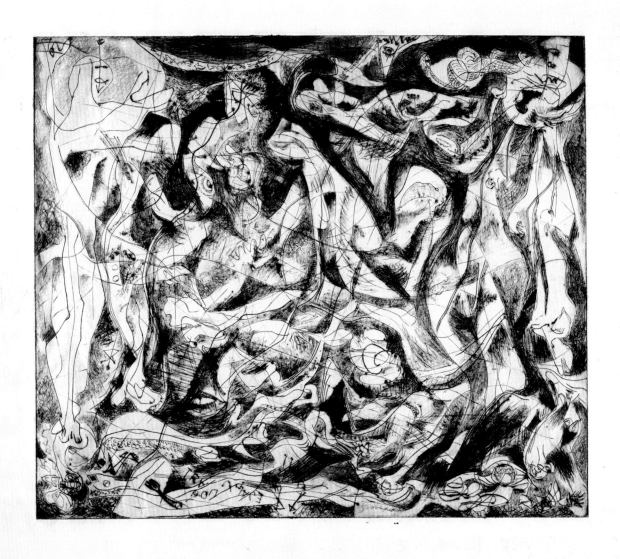

40 JACKSON POLLOCK

Untitled (4). 1944–45. Engraving and drypoint, plate: 14 15/16 x 17 5/8" (38 x 44.8 cm)

41–42 JOAN MIRÓ

Plate 4 and Plate 5 from the *Série noire et rouge* (Black and red series). 1938. Etchings, sheet (each): 12 13/16 x 17 3/8" (32.6 x 44.1 cm)

Miró realized his first significant work in etching, the *Série noire et rouge*, at the encouragement and instruction of painter Louis Marcoussis and executed the prints in Marcoussis's studio. The works demonstrate the creative potential of etching and of seriality in general. Miró made two copper plates and then experimented with their printing, rendering them both singly and in combination and in various orientations and colors, the process resulting in eight unique variations, including the two shown here.

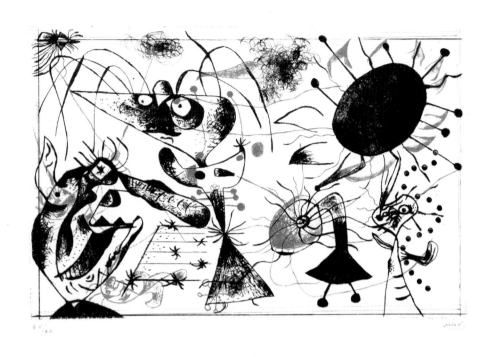

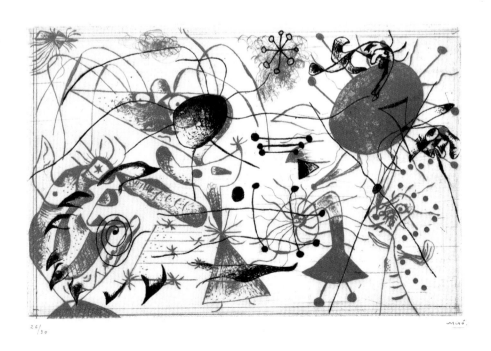

43–44 WOLS
(Alfred Otto Wolfgang Schulze)
Plate 1 and Plate 2 from the illustrated book *Naturelles* by René de Solier. 1946. Drypoints, sheet (each): 6 ⅜ x 4 ¹⁵⁄₁₆" (16.2 x 12.5 cm)

45 LOUISE BOURGEOIS
Plate 7 from the illustrated book *He Disappeared Into Complete Silence* by Louise Bourgeois. 1947. Engraving and drypoint, sheet: 10 x 6 ¹⁵⁄₁₆" (25.3 x 17.7 cm)

One of the more prolific printmakers of the twentieth century, Bourgeois experimented with intaglio at New York's Atelier 17, which was a nexus for expatriate artists in New York during the war years. There, she embarked on a project that she hoped would bring her work to a wider audience—a book of engravings, titled *He Disappeared Into Complete Silence*, accompanied by her own short texts, which she called "parables." The parable for Plate 7 reads: "Once a man was angry at his wife, he cut her into small pieces, made a stew of her. Then he telephoned to his friends and asked them for a cocktail-and-stew party. Then all came and had a good time."

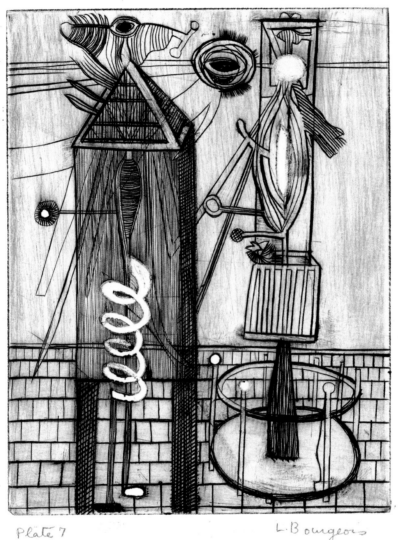

Plate 7 L. Bourgeois

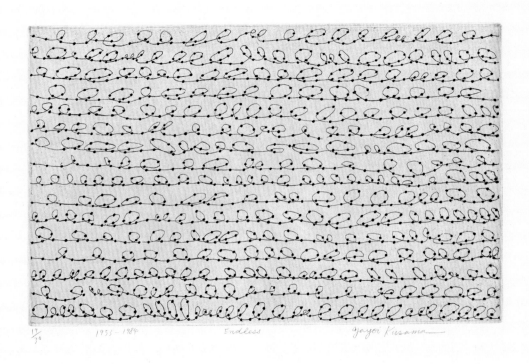

⁴⁶ **YAYOI KUSAMA**

Endless. 1953–84. Etching, sheet: 17 ¹¹⁄₁₆ x
24 ¾" (45 x 62.8 cm)

6/10

47 **GEGO**
(Gertrud Goldschmidt)
Balance. 1960. Etching, sheet: 14 ¹⁵/₁₆ x 11 ⅛"
(38 x 28.3 cm)

Gego immigrated permanently to Venezuela from her native Germany in the late 1930s, working as an architect and furniture designer before turning to sculpture, painting, draw-ing, and printmaking in the early 1950s. At the heart of her artistic practice is an investigation of line, as seen in her *Reticuláreas*: netlike structures rendered in mediums ranging from small works on paper to environmental, room-size sculptural installations. In *Balance*, a field of parallel, slightly irregular intaglio lines seems almost to ripple, offering a play of light and shadow.

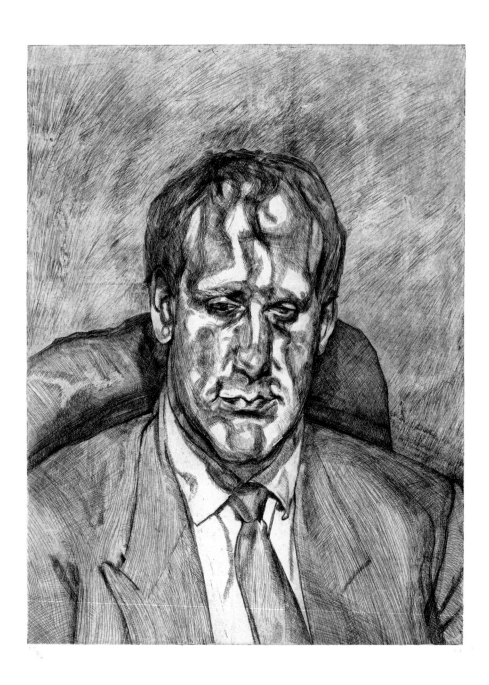

48 LUCIAN FREUD

Head of an Irishman. 1999. Etching, sheet:
38 ¼ x 30 ¾" (97.2 x 78.1 cm)

Copper plate for *Head of an Irishman*. 1999.
29 ⁵⁄₁₆ x 22 ⁵⁄₁₆" (74.5 x 56.6 cm)

Freud was a contemporary master of intaglio,
as evidenced by the uncompromising

etched portraits that form a major part of
his printed oeuvre. His expert linework can
be seen throughout *Head of an Irishman*—
from the sweeping contours of the sitter's
suit jacket to the dense crosshatches on the
hollows of his cheeks. Although the plate
has been wiped, some ink remains in the
incised lines, allowing the composition to
be easily made out.

21/25

YUKINORI YANAGI

Untitled from the portfolio *Wandering Position*. 1997. Etching, sheet: 24 ¹⁄₁₆ x 20 ¹⁄₁₆" (61 x 50.9 cm)

This image looks like an abstraction—a rectangle crisscrossed with slightly anxious, meandering lines that become denser at the edges. But in fact, as part of a larger project related to the idea of imprisonment, it is the product of a conceptual use of printmaking in which Yanagi put an ant on a metal plate and traced its movement with an etching needle as it attempted to escape. The density at the edges reflects the ant's efforts to bypass the barriers that the artist had placed around the perimeter of the plate.

50 JAMES SIENA

Upside Down Devil Variation. 2004. Engraving, plate: 19 x 14 ¹⁵⁄₁₆" (48.2 x 37.9 cm)

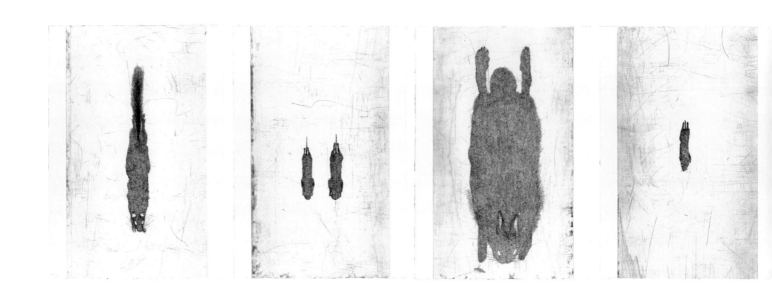

51 KIKI SMITH

White Mammals. 1998. Etching on seven sheets, sheet (each): 31 ⅜ x 22 ½" (79.7 x 57.2 cm)

Smith's passion for intaglio is evident in her intricate renderings of hair, fur, and feathers in images portraying birds and animals. For these prints, she tends to work from life—or more accurately from death—by consulting specimens from natural history museums. In *White Mammals,* made after examples in the collection of the Carnegie Museum of Natural History,

Smith focused on arctic or albino animals—like rabbits, squirrels, and ermine—that are engineered by nature to blend seamlessly into snowy environments. Her versions, however, render them starkly visible, in black ink.

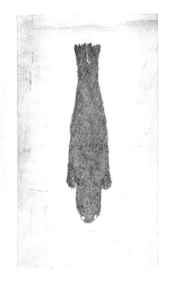

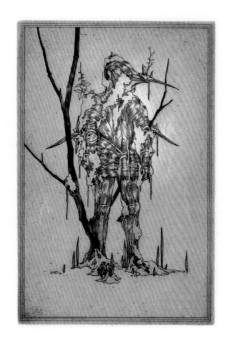

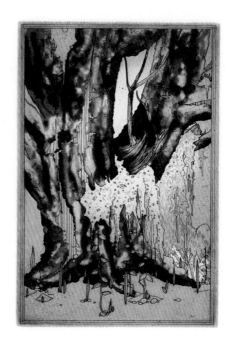

52–53 ERNESTO CAIVANO

Knight Interlude II and *Knight Interlude IX* from the portfolio *Knight Interlude*. 2005. Etching and aquatints, plate (each): 9 ⅜ x 6 ⅜" (23.8 x 16.2 cm)

54 JOSÉ ANTONIO SUÁREZ LONDOÑO

Untitled #199. 2002. Etching, sheet: 11 x 7 ½" (28 x 19 cm)

Printmaking is at the core of Suárez Londoño's intensely personal and intimate body of work, which draws on a rich array of sources including biology and mythology, art history and literature, geometry and architecture, flora and fauna, and the cosmos. Suárez Londoño works on a small, almost minute scale, drawing, etching, and printing his images himself and issuing only a couple of artist's proofs rather than a numbered edition.

55–56 ATSUKO TANAKA

Untitled and Untitled from the portfolio *for 1954*. 2005. One etching and aquatint and one etching, plate (each): 7 ¹¹/₁₆ x 5 ¾" (19.6 x 14.6 cm)

A member of Gutai, an experimental Japanese art group that arose in the mid-1950s, Tanaka often created work using nontraditional materials, a practice exemplified by her famous *Electric Dress* of 1956—comprised of blinking, colored lightbulbs and electrical wires, and worn by the artist as part of a performance. She proceeded to use that project's circular and linear forms as central motifs—almost compulsively so—for the rest of her life, as can be seen in these slightly frantic etchings, made nearly fifty years after the dress.

57 **FRED WILSON**

Arise! 2004. Aquatint and etching, plate:
19 ⅞ x 23 ⅞" (50.5 x 60.6 cm)

58 SHAUN O'DELL

Beyond When the Golden Portal Can Come.
2005. Aquatint and etching, sheet: 34 ½ x
29 ½" (87.6 x 74.9 cm)

59 JULIE MEHRETU

Refuge. 2007. Etching and aquatint, plate:
15 ¾ x 19 ½" (40 x 49.5 cm)

Layering maps, grids, charts, and architectural plans, Mehretu builds up abstract pictures that often suggest imagined places. She seems to have a natural predilection for intaglio mediums, with their clean, precise lines. For *Refuge*, Mehretu took a relatively loose approach, creating aquatint areas that evoke the tonal grays of billowing clouds or puffs of smoke, and subtly colored vector lines that give the composition structure and a sense of dynamism.

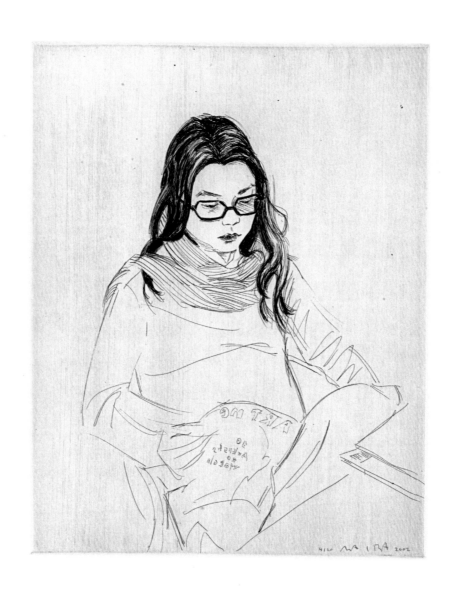

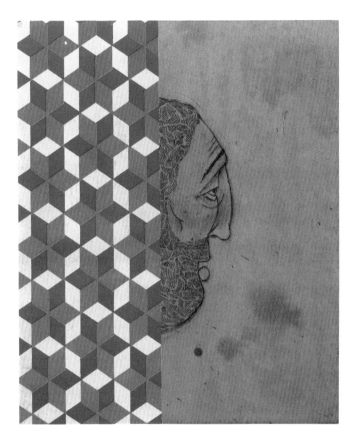 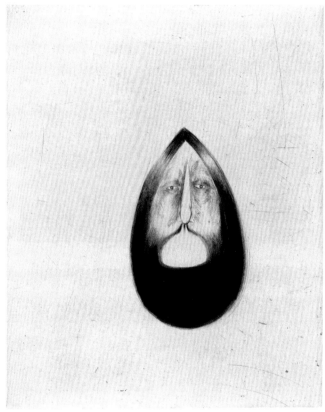

60 **ELIZABETH PEYTON**

Rirkrit Reading. 2002. Etching, plate: 9 ¹³⁄₁₆ x 7 ⅞" (25 x 20 cm)

61–62 **BARRY McGEE**

Untitled and Untitled from the portfolio *Drypoint on Acid*. 2006. One etching and aquatint with chine collé and collaged screenprint additions and one drypoint with chine collé, sheet: 7 ¹³⁄₁₆ x 6 ⅜" (19.8 x 16.2 cm) and 7 ¹⁵⁄₁₆ x 6 ⁷⁄₁₆" (20.1 x 16.4 cm)

McGee is known as much for his role in graffiti and skate culture as for the painting and printmaking in which he was trained. Inspired by contemporary urban culture, he often incorporates in his work found objects and detritus such as empty alcohol bottles, scraps of wood and metal, and discarded signs. His signature "sad sack" figures, suggestive of homeless or transient people, are seen throughout this portfolio, which features collage elements from his vast collection of old printed papers.

⁶³ **KARA WALKER**

An Unpeopled Land in Uncharted Waters.
2010. Etching and aquatints, sheet (each):
30 ¼ x 11 ⅞–40 ¾" (76.8 x 30.2–103.5 cm)

In disturbing, often violent, and sometimes
humorous scenes of the antebellum South,
Walker reinvigorates the nineteenth-
century art of paper silhouette and invests
it with new agency. These six images, in
which inky black aquatint tones echo the
effect of her paper cutouts, suggest chapters
in an enigmatic narrative set during the
discovery of the New World and the subse-
quent Atlantic slave trade.

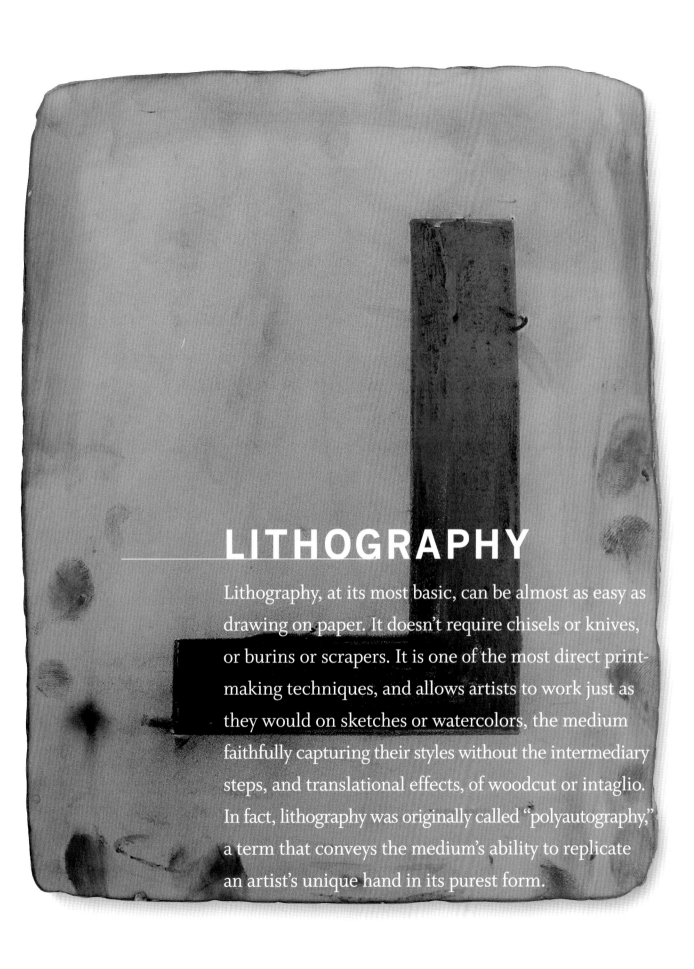

LITHOGRAPHY

Lithography, at its most basic, can be almost as easy as drawing on paper. It doesn't require chisels or knives, or burins or scrapers. It is one of the most direct print-making techniques, and allows artists to work just as they would on sketches or watercolors, the medium faithfully capturing their styles without the intermediary steps, and translational effects, of woodcut or intaglio. In fact, lithography was originally called "polyautography," a term that conveys the medium's ability to replicate an artist's unique hand in its purest form.

Unlike woodcut and intaglio, which have an inherent physicality to them, lithography is a chemical medium based on the principle that oil and water don't mix. Drawings are made with a greasy material—anything from chalks or crayons in different grades of hardness to liquid tusche applied with a brush—on a printing matrix (historically, thick slabs of specially prepared limestone; though today zinc or aluminum plates are more common, as they are easier to work with). The matrix is brushed with a chemical solution—consisting of gum arabic (a water-soluble resin) and a bit of acid—that helps bond the drawing to the surface. Then it is wiped down with a solvent, such as turpentine, which dissolves most of the drawing but leaves a greasy, ghosted version of it. Next, the stone or plate is moistened with water, which is absorbed only by the blank areas. An oil-based printing ink is applied, adhering to the positive parts of the image while being repelled from the wet, negative parts. The inked matrix is placed on the bed of a press with a sheet of damp paper on top, and is run through the machine. In a later variation known as offset, the image is transferred first to a rubber blanket and then to the matrix, allowing it to be printed in the same orientation in which it was rendered (rather than in reverse). Offset allows for the inexpensive production of large quantities, and because of this it is one of the most widely used printing techniques today, particularly for commercial applications including newspapers, magazines, and postcards.

Of the printmaking techniques, lithography has the best-documented history. It was invented in 1789 by Alois Senefelder (1771–1834) in Munich. Senefelder was not an artist, but rather an aspiring actor and playwright, and he was seeking a means of inexpensively reproducing copies of his works. Apparently by accident, he invented what he called chemical or stone printing, and went on to champion the technique throughout Europe while continuing to refine it by experimenting with various equipment and ink formulations, color printing, and transfer lithography (which today is done with a special kind of water-soluble paper that ultimately dissolves,

leaving only the image and allowing the artist not to have to draw in reverse). He also saw lithography's potential as an art medium, and one of his British colleagues commissioned artists to try it out, which resulted in a portfolio called *Specimens of Polyautography* (1803).

Lithography was a particularly big hit in France, and by 1838 Paris was home to more than 280 print workshops. The medium had a tremendous impact on visual culture, as it was used for everyday materials like posters, broadsides, handbills, advertisements, and publications. Honoré Daumier (1808–1879) made around four thousand lithographs. Primarily social and political caricatures, they reached a large audience due to their appearance in satirical journals such as *La Caricature* and *Le Charivari*.

While some printmaking mediums initially carried the stigma of craft, lithography quickly found adherents at the highest level of art, including painters Edgar Degas, Paul Cézanne, and Paul Gauguin. Ambitious print-specific publications arose, such as *L'Estampe Originale* (1893–95), a quarterly series of portfolios that featured original works by, among others, Pierre Renoir and Odilon Redon. Henri de Toulouse-Lautrec was one of the titans of lithography in 1890s Paris. Among his prints were contributions to portfolios and publications, posters advertising everything from the amusements of the café-concerts and their celebrated performers to newly invented paper confetti, and illustrations for deluxe book collaborations with like-minded authors.

The so-called print boom arrived much later in the United States, and can be traced back, in part, to workshops founded in the late 1950s and early 1960s. One of them, Tamarind Lithography Workshop, was created at the instigation of painter and printmaker June Wayne, with financial support from the Ford Foundation. Tamarind was established to train people in the seemingly lost art of lithography and then, ideally, send these master printers out as ambassadors for the medium. Today, Tamarind has relocated its facilities from Los Angeles to Albuquerque, New Mexico, where it continues its mission, with Tamarind-trained printers now based in locations around

the world, from the Tokyo suburbs to Newcastle-upon-Tyne, England, to White River, Mpumalanga, South Africa.

On the East Coast, Tatyana Grosman established Universal Limited Art Editions (ULAE) in 1957, proselytizing tirelessly for lithography at a time when many people viewed the medium as old-fashioned. Eventually she persuaded New York-based artists including Lee Bontecou, Barnett Newman, and Larry Rivers to give it a try. When lithographic stones were first delivered to Jasper Johns's studio in 1960, they were so heavy that he asked his downstairs neighbor, Robert Rauschenberg, to help him carry them up the stairs. Both artists became dedicated printmakers and worked extensively with ULAE, which continues today with an expanded range of techniques under the direction of longtime master printer William Goldston.

Like the other printmaking techniques, lithography is able to capture intermediate stages of an artist's composition as it evolves from early to completed states. Pablo Picasso is among the artists who exploited this capacity of the medium. His series *Le taureau* (Bull, 1945–46; pls. 70–72), undertaken in collaboration with master printer Fernand Mourlot, began with an image of a solid, muscular bull in inky black tones. Almost immediately, the artist started breaking down the bull into an increasingly schematized view, flummoxing the printers in the shop, who felt the process was moving in reverse, at which point he joked that the bull could be hung in the butcher's shop so that housewives could point to which cut of meat they wanted. Picasso continued to reduce the image until the bull became an icon, striking in its economy and simplicity. Through the artist's state proofs, we are able to follow the journey of the image, one that might otherwise be rather hard to believe, and that in another medium would have been erased or painted over.

The extraordinary range of mark-making that lithography facilitates can be seen in the examples that follow in the plates section. George Bellows, considered one of the American masters of the technique, produced the immediacy of a sketch from life in a 1923 portrait of his then-eight-year-old

daughter, Jean (pl. 74). When Willem de Kooning, one of the great painters of the New York School, was persuaded to try the medium for the first time in 1960, he used a cleaning mop as a brush while working on a large stone placed on the floor, creating a gestural image of tremendous impact (pl. 77). The artist's hand, however, is not always so visible. Lorna Simpson used lithography to reproduce photographs she had taken of wigs (pl. 88), printing the images on felt panels and combining them with text in an installation that addresses issues of race, gender, and identity.

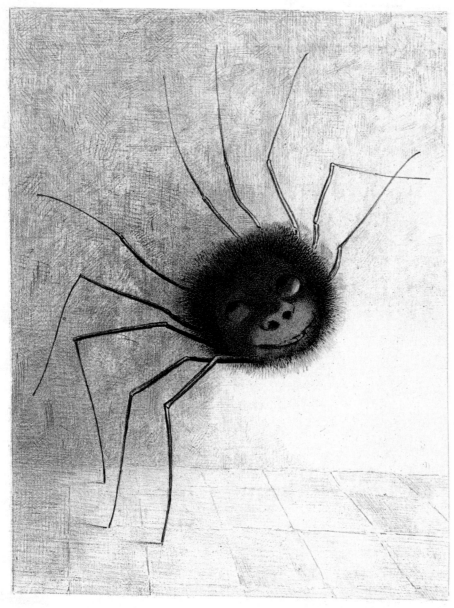

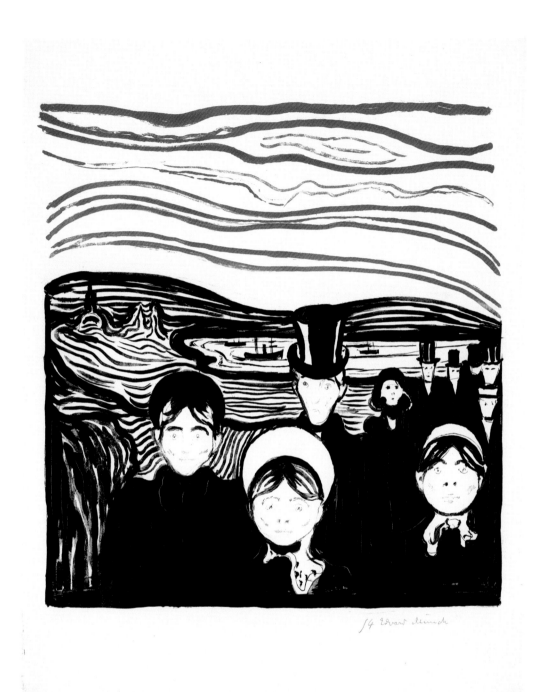

64 ODILON REDON

Araignée (Spider). 1887. Lithograph, composition: 11 x 8 9/16" (28 x 21.7 cm)

Closely associated with Symbolism, an artistic and literary movement that rejected naturalism in favor of ideas and images drawn from dreams and the imagination, Redon created a panoply of hybrid creatures, including the smiling spider seen here. Considered a master of lithography, he was able to coax a seemingly endless spectrum of grays from the medium, and to capture difficult textures, as in the feathery powder puff of the spider's body. The artistic acclaim and reputation that Redon enjoyed during his lifetime was likely due in part to the wide distribution, through editioning, of his body of nearly 250 prints.

65 EDVARD MUNCH

Angst (Anxiety). 1896. Lithograph, composition: 16 5/16 x 15 3/8" (41.4 x 39.1 cm)

66 HENRI DE TOULOUSE-LAUTREC

Miss Loïe Fuller. 1893. Lithograph, sheet: 14 15/16 x 11 1/8" (38 x 28.2 cm)

A singularly important figure in the development of color lithography in France in the 1890s and a uniquely devoted printmaker, Toulouse-Lautrec portrayed contemporary city life in settings ranging from cafés and artistic salons to dance halls and brothels. For this experimental lithograph, he depicted the dancer Loïe Fuller in almost abstract terms, with a spatter technique that gives the image a sense of movement and the shimmering ephemerality of the subject's dance. Each of the approximately sixty impressions was unique in its color scheme, and this one was also dusted with golden powder.

67 EL LISSITZKY

Untitled from the portfolio *Proun*. 1919–23. Lithograph with collage additions, sheet: 23 ¾ x 17 ⅜" (60.3 x 44.1 cm)

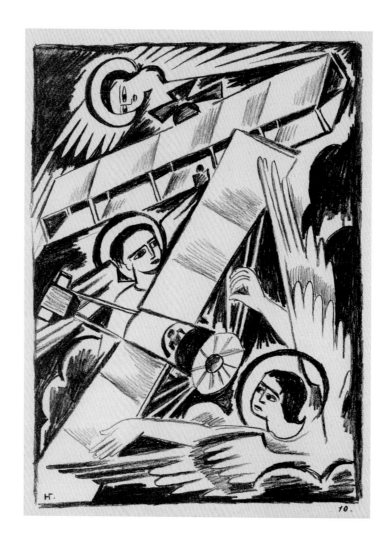

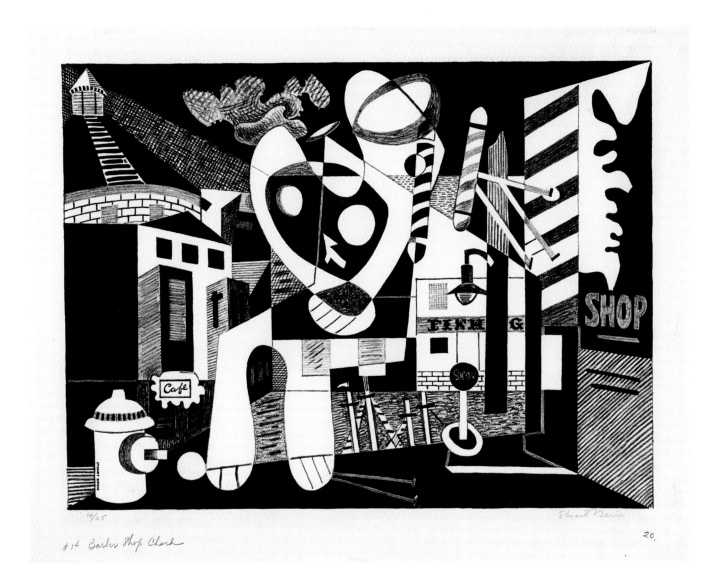

14/25　　　　　　　　　　　　　　　　　　　　　　Stuart Davis

#14 Barber Shop Chord　　　　　　　　　　　　　　　　20.

68 NATALIA GONCHAROVA

Angely i aeroplany (Angels and airplanes) from the portfolio *Misticheskie obrazy voiny. 14 litografii* (Mystical images of war. 14 lithographs). 1914. Lithograph, sheet: 12 ⅞ x 9 ⁷⁄₁₆" (32.7 x 24 cm)

69 STUART DAVIS

Barber Shop Chord. 1931. Lithograph, sheet: 17 ¼ x 21 ⅝" (43.8 x 54.9 cm)

Demonstrating the range of Davis's experimentation with lithography, *Barber Shop Chord* features an array of tones and textures—including dense blacks, crosshatched shading, aggressively patterned diagonals—as well as signage in multiple fonts. Although Davis was inspired by Paris and the art he had seen there during a recent sojourn, this work refers more directly to the seaside town of Gloucester, Massachusetts—where the artist spent his summers—as evidenced by the water tower that appears at the top left and the tackle shop underneath the streetlamp.

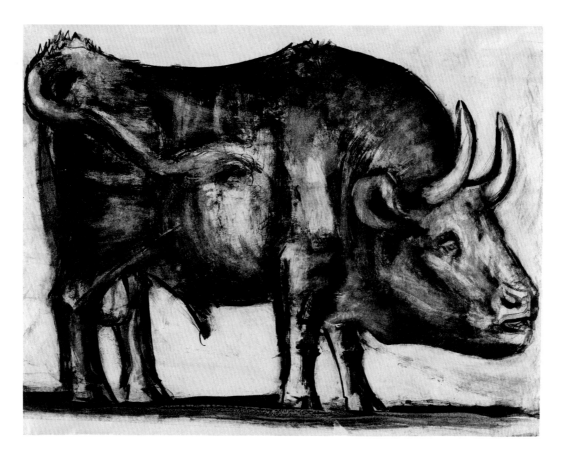

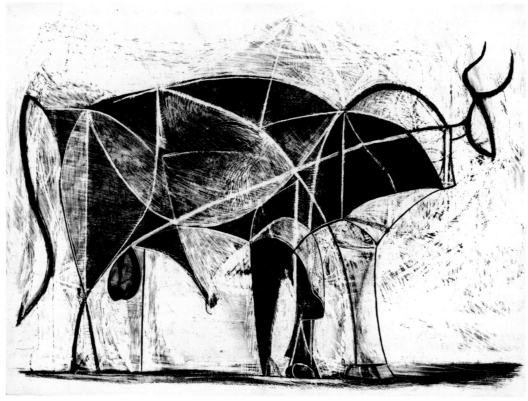

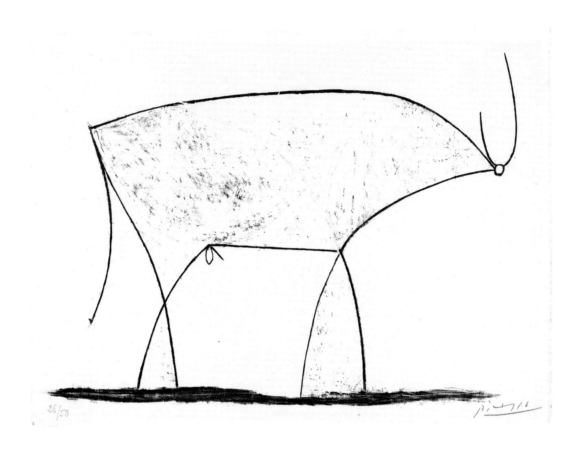

26/50

70–72 **PABLO PICASSO**

Le taureau (Bull), state III. December 12, 1945. Lithograph, sheet: 13 1/16 x 17" (33.2 x 43.2 cm)

Le taureau (Bull), state VII. December 26, 1945. Lithograph, sheet: 12 15/16 x 17 1/2" (32.8 x 44.4 cm)

Le taureau (Bull), state XIV. January 17, 1946. Lithograph, sheet: 13 1/16 x 17 1/2" (33.2 x 44.4 cm)

For Picasso, spurts of artistic activity were often prompted by the arrival of a new collaborator, whether passive—in the form of a love or muse, for example—or active, as with the master printers who facilitated his extraordinary printmaking experiments.

Lithographic printer Fernand Mourlot was one such key figure, and with his assistance Picasso produced audacious works like *Le taureau*. Picasso first drew the realistic bull at the top left, and then began reworking the figure, printing the intermediate stages in order to track its evolution, until he eventually reduced it to the near-hierogylph that appears above.

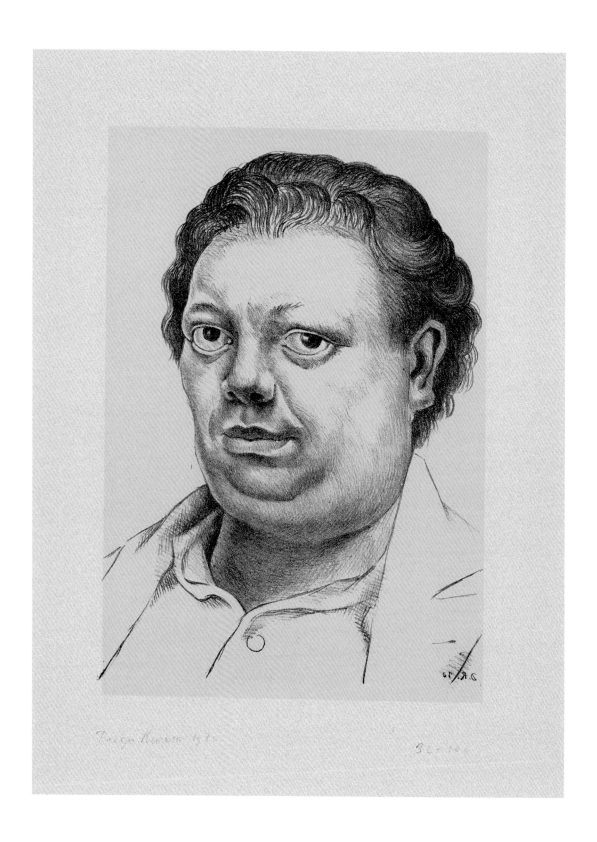

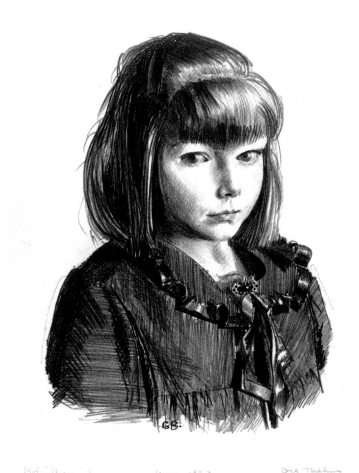

<u>73</u> DIEGO RIVERA

Autoretrato (Self-portrait). 1930. Lithograph, composition: 15 ⅞ x 11 ¼" (40.3 x 28.6 cm)

Rivera's approach to printmaking was markedly different from that of El Taller de Gráfica Popular, a collective print workshop that focused on political messages and broad distribution and that represented a predominant strand of printmaking in Mexico at the time. Rivera made only a handful of prints in his career, including details of the famous murals for which he is best known, scenes of contemporary life, portraits of friends and family, and the beautifully drawn self-portrait seen here.

<u>74</u> GEORGE BELLOWS

Jean. 1923. Lithograph, sheet: 14 ½ x 12 ½" (36.8 x 31.9 cm)

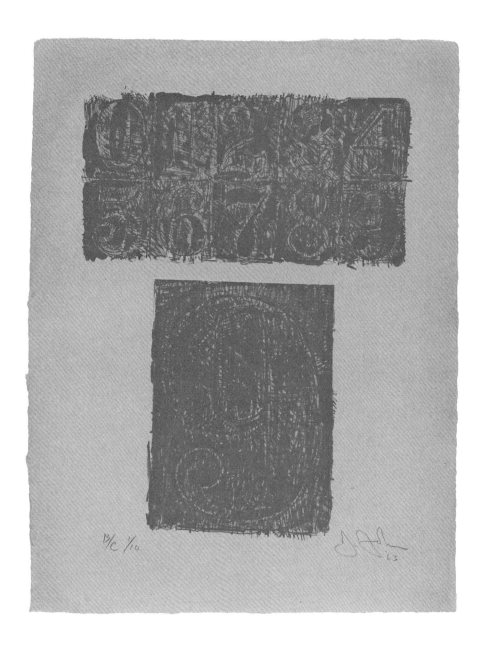

75 JASPER JOHNS

9 from the portfolio *0–9 (Gray)*. 1963.
Lithograph, sheet: 20 ¼ x 15 ⅞"
(51.5 x 40.3 cm)

Stone from the portfolios *0–9 (Black)*,
0–9 (Color), and *0–9 (Gray)*. 1960–63.
Lithographic stone, inked in white and
varnished, 18 x 14 x 2 ¾" (45.7 x 35 x 7 cm)

The project *0–9* consists of ten individual
images, each of which depicts a single
numeral with a grid of numbers above it.
Johns editioned the project in three
variations—in color, in black, and in gray.
He would print all the impressions of
one numeral in the three color schemes,
using the single lithographic stone seen at
right, and then efface that numeral and

draw the next one in its place. Taken
together, the portfolios are a testament
to the creative possibilities and serial
potential of lithography. The number 9,
the last to be represented, remains on
the stone.

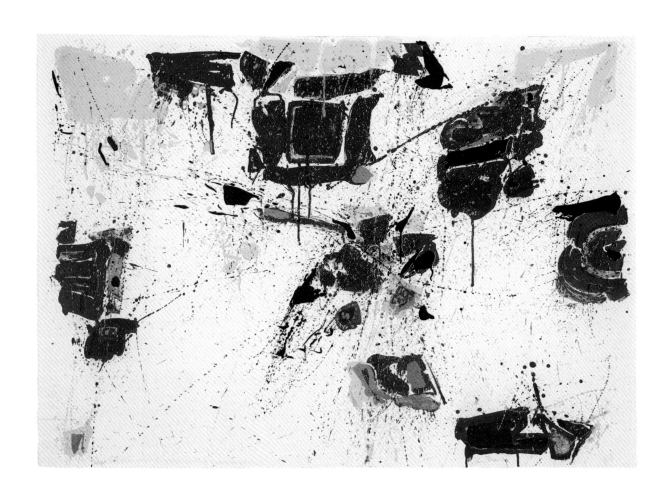

<u>76</u> SAM FRANCIS

The Upper Yellow. 1960. Lithograph, sheet: 24 ⅞ x 35 ¹¹⁄₁₆" (63.2 x 90.6 cm)

Francis found printmaking such a compelling means of furthering his project of abstraction, previously carried out primarily in painting, that in 1970 he opened his own printmaking workshop, The Litho

Shop, with its own staff of master printers with whom he could collaborate. Although he also worked extensively with intaglio and screenprint, lithography—with its capacity for gestural improvisation and spontaneity and its ability to capture the drips, splashes, and splatters of loose brushwork—became a central aspect of his practice.

<u>77</u> WILLEM DE KOONING

Litho #2 (Waves #2). 1960. Lithograph, sheet: 45 ⅞ x 31 ¾" (116.6 x 80.7 cm)

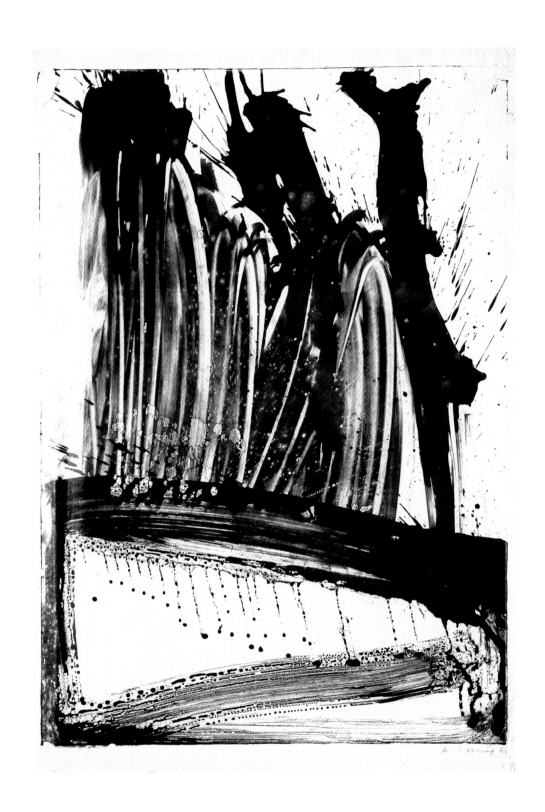

78 JEAN DUBUFFET

Angle de mur à l'oiseau perché (Bird perched on the corner of the wall) from the illustrated book *Les Murs* (Walls) by Eugène Guillevic. 1945. Lithograph, sheet: 14 ⅜ x 11" (36.5 x 27.9 cm)

With a rebellious attitude toward traditional ideas of high culture and good taste, Dubuffet sought approval from "the man in the street" rather than from critics and often depicted the back streets and tenement facades familiar to the average Parisian. In his prints for Eugène Guillevic's book *Les Murs*, Dubuffet merged form and content by utilizing lithography—a medium in which compositions are rendered on stone—to create images of the city's walls. He used different densities of tusche to achieve the various textures of the surfaces.

79 ELLSWORTH KELLY

Red Over Yellow from the series Suite of Twenty-Seven Color Lithographs. 1964–65. Lithograph, sheet: 35 ¼ x 23 ½" (89.5 x 59.7 cm)

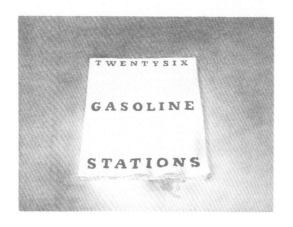

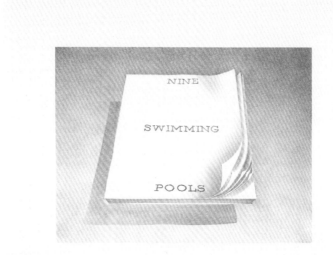

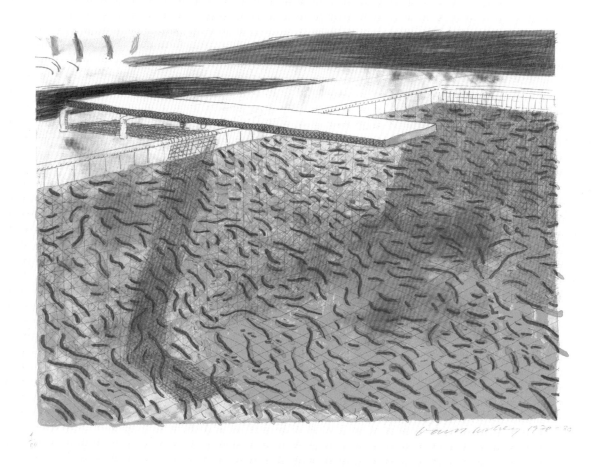

Twentysix Gasoline Stations from the series Book Covers. 1970. Lithograph, sheet: 16 ⅛ x 20 ³⁄₁₆" (41 x 51.2 cm)

Nine Swimming Pools from the series Book Covers. 1970. Lithograph, sheet: 16 ⅛ x 20 ³⁄₁₆" (41 x 51.2 cm)

82 **DAVID HOCKNEY**

Lithograph of Water Made of Thick and Thin Lines, a Green Wash, a Light Blue Wash, and a Dark Blue Wash. 1978–80. Lithograph, sheet: 26 x 34 ½" (66 x 87.6 cm)

Hockney has incorporated the image of the swimming pool—a reference to his adopted hometown of Los Angeles—throughout his work. Between 1978 and 1980, he pursued the motif in an extensive artistic investiga-tion that resulted in numerous paper-pulp pieces as well as nearly a dozen printed variations, of which this is one. For the prints, he worked from an assortment of lithographic stones and plates—which featured different compositional elements, from grids of lines to fields of thick or thin squiggles—varying their combinations to suggest, in an impressionistic style, multiple moods and moments in relation to the same scene.

83 ELIZABETH MURRAY

States I–V. 1980. Lithographs, sheet (each):
22 ¹/₁₆ x 17 ¹⁵/₁₆" (56 x 45.5 cm)

Murray said that these, her first professional
prints, were inspired by Picasso's *Le taureau*
lithographs (pls. 70–72), which she had seen
that year in a retrospective of the artist's

work at The Museum of Modern Art. Inter-
ested in tracing her image's development
through states, Murray worked on a single
stone with lithographic crayon and tusche,
adding color only at the fourth print and
printing the stone twice in different orien-
tations for the fifth.

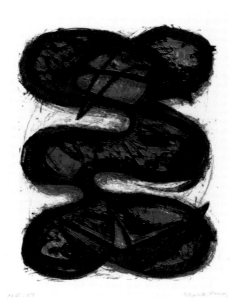

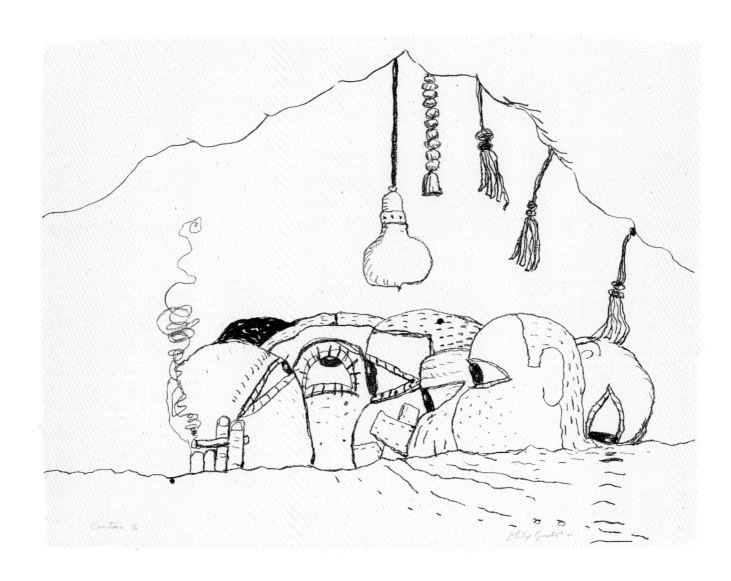

84 **PHILIP GUSTON**

Curtain. 1980, published 1981. Lithograph,
sheet: 30 ¹¹⁄₁₆ x 40 ¾" (77.9 x 103.5 cm)

Ran away, Glenn Ligon. He's a shortish broad-shouldered black man, pretty dark-skinned, with glasses. Kind of stocky, tends to look down and turn in when he walks. Real short hair, almost none. Clothes non-descript, something button-down and plaid, maybe, and shorts and sandals. Wide lower face and narrow upper face. Nice teeth.

RAN AWAY. Young guy – the Oliver North of downtown. 5 feet, + and then some. Medium build, stylishly casual (usually in jeans). Soft-spoken, well-spoken but kinda' quiet. Wears delicate glasses. Moves smoothly, looks like he might have something on his mind – he'll find you.

85–86 **GLENN LIGON**

Untitled and Untitled from the portfolio *Runaways*. 1993. Lithographs, sheet (each): 16 x 12" (40.7 x 30.5 cm)

Ligon based *Runaways* on historical printed matter: nineteenth-century advertise-ments—distributed on broadsides or printed in Southern newspapers—seeking the return of runaway slaves. For his versions, Ligon asked friends to provide descriptions of him, and then he incorporated their responses—which detailed his physical attributes, wardrobe preferences, mannerisms, and personality traits—into ten prints.

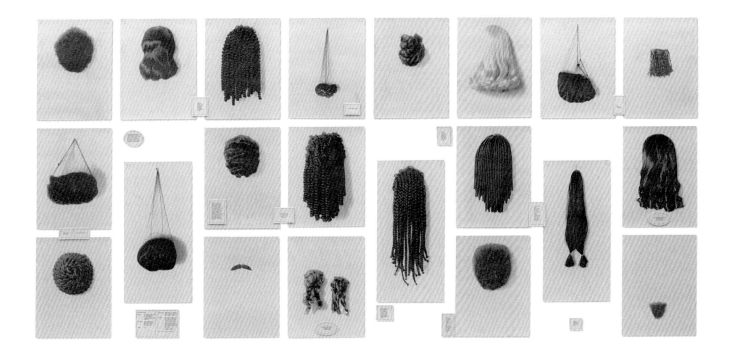

⁸⁷ TERRY WINTERS

Factors of Increase. 1983. Lithograph, sheet:
31 ¾ x 23 ¾" (79.7 x 60.3 cm)

Winters made *Factors of Increase*—only his
second lithograph—at the invitation of
Universal Limited Art Editions, which at the
time was introducing the next generation
of artists after Johns and Rauschenberg
to printmaking. Here, Winters juxtaposes
the greasy, smudgy marks of lithographic
crayon with the delicate deckled edge
of a sheet of handmade paper in a work
that speaks to his interest in biological
processes, architectural forms, and techno-
logical networks.

⁸⁸ LORNA SIMPSON

Wigs (Portfolio). 1994. Lithographs on felt,
overall: 6' x 13' 6" (182.9 x 411.5 cm)

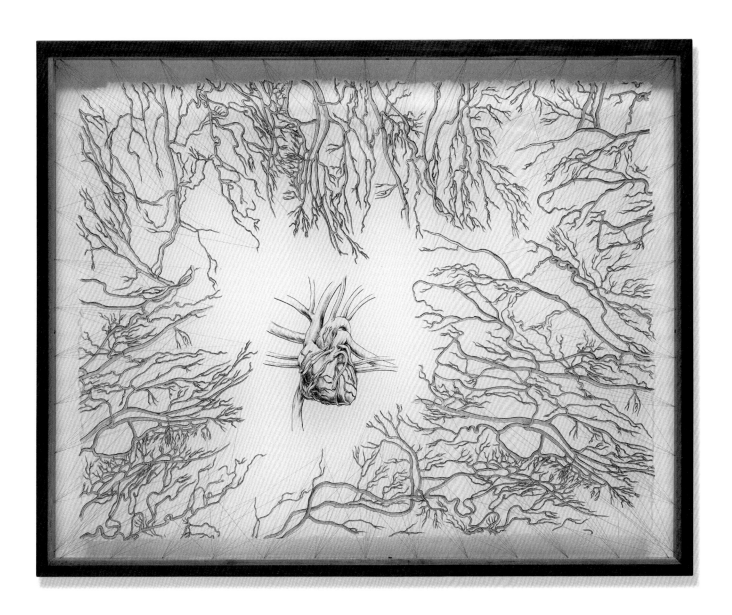

89 ROBERT GOBER

Untitled. 2002. Lithograph, sheet: 51 ¹⁄₁₆ x
36 ¹⁄₁₆" (129.7 x 91.6 cm)

90 TABAIMO

show through II. 2009. Lithograph with
monofilament in wooden frame, 36 ½ x
46 ½ x 1 ¾" (92.7 x 118.1 x 4.4 cm)

Drawing on the aesthetics of traditional
Japanese *ukiyo-e* woodcuts, Tabaimo
explores what lies beneath the seeming
orderliness of the everyday world and the

bodies that populate it. In *show through II*,
an image of a heart is printed on a spe-
cially prepared sheet of gampi tissue that
has the curling, yellowed effect of dead
skin and that has been stitched into place
with monofilament.

SCREENPRINT

Screenprint, also known as silkscreen or serigraphy, was developed in the past century, but its origins are prehistoric. The technique is essentially a process of stenciling, an activity that has its roots in the pigment handprints humans made some thirty-two thousand years ago on the walls of caves in what is today France. Stencils were used in Asia as early as 500 AD for textile printing, and were adopted in Europe by the fifteenth century as a means of adding color to printed pictures.

There are numerous ways to make a screenprint. Most commonly, an artist cuts an image into a sheet of paper or plastic. The cut areas are removed to create a stencil, which is then affixed to a screen made of fine mesh fabric (originally silk) stretched onto a frame. The frame is placed on a sheet of paper or other support; ink is then spread along the top of the screen and pulled down the fabric with a rubber blade, or squeegee, getting squeezed through the open, cut-away areas of the stencil. The uncut portions block the ink from penetrating the mesh, and create blank areas in the print. When the screen is lifted away, the composition appears in its original orientation on the support. Different screens are used for different colors.

In the United States, screenprint initially developed as a commercial enterprise, having been adopted for the production of advertisements in the late nineteenth century. Color screenprints were often made in a compressed manner, with an artisan cutting the different-colored areas of a composition from a single screen, working progressively from the largest portions to the smallest and masking out areas of the composition with glue along the way. By 1916, new developments enabled photographic images to be incorporated on screens, and within a few years the printing process had been automated, allowing many impressions to be printed quickly.

Artists picked up the medium in the 1930s, and it soon became a key vehicle for social and political messages. A screenprint unit of the Works Progress Administration was founded in 1939, and shortly thereafter rechristened the medium "serigraphy" in an attempt to distance the practice from its commercial origins. The group commissioned screenprints, signs, and posters that promoted community events, cultural programs, and issues of health and safety.

In the 1960s, screenprint emerged again as a means for communicating ideas in the face of social upheaval. During the uprisings in Paris in 1968, a guerrilla student workshop, Atelier Populaire, was set up at the École des Beaux-Arts to produce posters publicizing their causes. They would make screenprints at night that responded to events of the day, and plaster them

around town before the next morning. Although the police tried to find and silence the source of the revolutionary graphics that were filling the city, they were looking for a big printing apparatus, and not just the modest, stretched screens that were actually being used. Thus, the group remained under the radar and free to continue their activities.

Pop artists seeking to reclaim and recast popular culture found that screenprint—with its commercial origins and its propensity for bold, flat areas of color—was the perfect medium for their message. Printmaking was part of Roy Lichtenstein's practice since his student days, and for his signature images—inspired by comics as well as what was considered, by contrast, "high art"—he used the strategies and visual language of commercial printing. In *Sweet Dreams, Baby!* (1965, published 1966; pl. 97), the benday dots, bold contours, and unmodulated color blocks exemplify screenprint's particular strengths. In fact, Lichtenstein retained this same visual vocabulary even when working in other mediums, from lithography to paint on canvas.

Often working in screenprint rather than painting, Thomas Bayrle began developing a trademark style of intricately designed images in the 1960s. Bayrle offers a play between figure and ground in his compositions, portraying subjects as dense patterns of small repeating figures, objects, or streetscapes and against similarly patterned backgrounds. These subjects are taken from everyday life, as in *American Dream (Chrysler)* (1970; pl. 101), which conveys the voraciousness and monotony of our consumer culture—in a medium that is itself based in mass-production and commerce—through the seemingly endless replication of Chrysler's star-shaped logo.

Andy Warhol first found success as a commercial artist, making magazine illustrations and advertisements, and this aesthetic carried over to his work in other mediums. Screenprint offered the defining language for his art, and its characteristics were incorporated even in his unique images on canvas. In his famed 1967 series reproducing a publicity photograph of Marilyn Monroe (pls. 103–106), Warhol exploited the medium's potential for sequencing and variation by having the screens layered and printed in different colors and

off-register, a process that resulted in ten unique takes on a single image, each with its own mood and sensibility.

Hannah Wilke, a central figure in the development of performance and body art in the United States beginning in the 1970s, made the screenprint *Marxism and Art: Beware of Fascist Feminism* (pl. 113) in 1977. In the heyday of a consolidated feminist movement, Wilke's radical practice had drawn a leery, and sometimes critical, response from those who questioned the role that her own beauty sometimes played in her work. She offered a response in this image, in which she paired the aggressive title statement with an extant portrait of herself bare-breasted and dotted with chewing gum, rejecting the idea of feminism as an organized entity with universally shared goals and guidelines. In addition to this screenprint—planned as an edition of twenty-five, though only one was ultimately executed—Wilke produced a version of the work as an offset poster that she plastered around SoHo in New York.

In form and practice, Ryan McGinness can be seen as a descendent of Warhol. McGinness draws on popular culture, graphic design, and art history to create complex layered compositions. For the series Fabricated Cultural Belief Systems (2004; pl. 116), he worked from a set assortment of screens, printing them in various combinations, orientations, and colors to create one hundred discrete images that address issues at the heart of screenprint—seriality and uniqueness, repetition and difference.

"Red and Black" Ralston Crawford

91 RALSTON CRAWFORD

Red and Black (*U.S.S. Nevada*). 1949.
Screenprint, sheet: 17 3/16 x 23 3/8"
(43.7 x 59.4 cm)

92 WILLIAM H. JOHNSON

Blind Singer. c. 1940. Screenprint with
tempera additions, sheet: 17 1/2 x 11 1/2"
(44.5 x 29.2 cm)

Johnson's prints range from woodcuts
and linoleum cuts inspired by German
Expressionism to screenprints and

pochoirs that capture aspects of contempo-
rary African-American life, showing, for
instance, black soldiers during World War II
or the vibrant arts scene of the Harlem
Renaissance. This image, likely inspired by
a popular blind blues guitarist, demonstrates
the bold, flat coloring enabled by screenprint.

93–94 JOSEF ALBERS

Patina and *Aura* from the portfolio *Homage to the Square: Ten Works by Josef Albers*. 1962. Screenprints, sheet (each): 16 15/16 x 16 15/16" (43 x 43 cm)

Teaching was vital to Albers's practice. He was an instructor at the Bauhaus in the 1920s, at Black Mountain College in the 1930s and '40s, and at Yale beginning in 1950.

During this last period, his interest in color began to manifest itself in a now-famous series of paintings and prints known as Homage to the Square, the compositions of which feature nested squares in different values and hues. The works shown here were among the first prints in the series, and were produced in collaboration with two of Albers's students, Norman Ives and Sewell Sillman.

95 BRIDGET RILEY

Untitled (Based on Movement in Squares). 1962. Screenprint, sheet: 20 1/2 x 20 1/2" (52 x 52 cm)

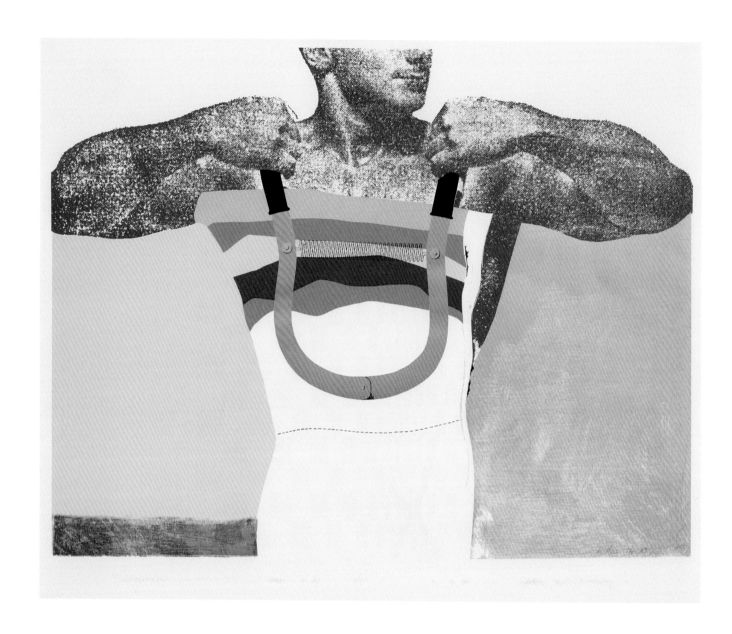

96 RICHARD HAMILTON

Adonis in Y Fronts. 1963. Screenprint, sheet: 26 ½ x 33 ⁵⁄₁₆" (67.3 x 84.6 cm)

This work, Hamilton's first screenprint, is an elaboration on a painting he had made the year before. A pioneer of British Pop, he combined several mass-media images in the screenprint, including a photograph of a classical Greek sculpture from *Life* magazine, an advertisement for bodybuilding equipment, and an illustration from *Playboy*. Hamilton became a major practitioner of and advocate for the medium, saying that it "has a certain appeal also because it is less autographic than etching or litho—it hasn't their dependence on the hand of the artist: in that sense it is a modern print-maker's medium."

97 ROY LICHTENSTEIN

Sweet Dreams, Baby! from the portfolio *11 Pop Artists*, volume III. 1965 (published 1966). Screenprint, sheet: 37 ¹¹⁄₁₆ x 27 ⁵⁄₈" (95.7 x 70.2 cm)

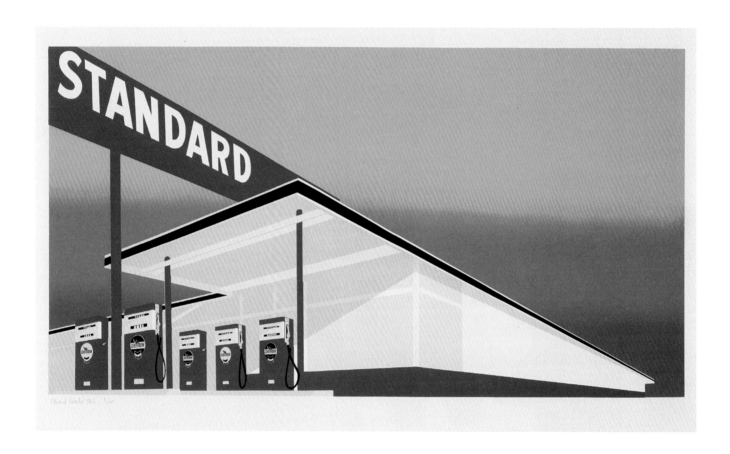

98 **EDWARD RUSCHA**

Standard Station. 1966. Screenprint, composition: 19 ⅝ x 36 ¹⁵⁄₁₆" (49.6 x 93.8 cm)

The Standard gas station first appeared in Ruscha's work in 1963, in a photograph included in his seminal artist's book *Twentysix Gasoline Stations*. The image soon followed in both painted and printed

versions, and has since become a signature motif. In 1969, Ruscha returned to the screens he had used for that first printed version and, by experimenting with different-colored inks and additional screens, made the variations seen at right.

99 **EDWARD RUSCHA** with **MASON WILLIAMS**

Double Standard. 1969. Screenprint, composition: 19 ⅝ x 36 ¹⁵⁄₁₆" (49.6 x 93.8 cm)

100 **EDWARD RUSCHA**

Cheese Mold Standard with Olive. 1969. Screenprint, composition: 19 ⅝ x 36 ¹⁵⁄₁₆" (49.6 x 93.8 cm)

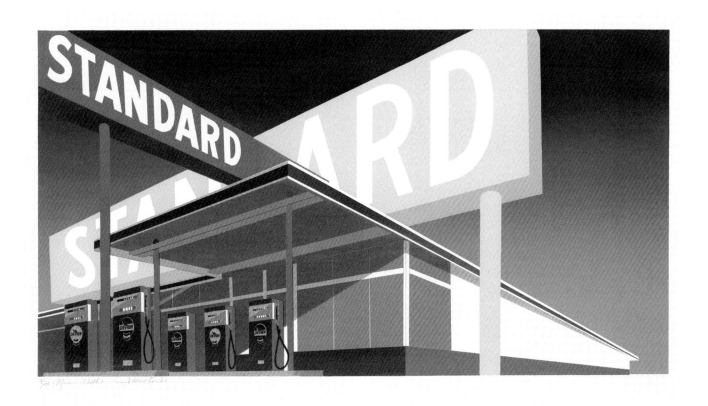

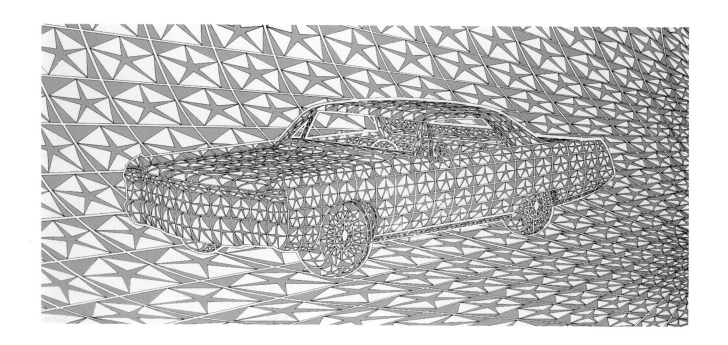

101 **THOMAS BAYRLE**

American Dream (Chrysler). 1970.
Screenprint, sheet: 15 ½ x 34"
(39.3 x 86.3 cm)

102 GERHARD RICHTER

Flugzeug II (Airplane II). 1966. Screenprint, sheet: 24 x 33 ⅞" (61 x 86 cm)

Photography is an important tool for Richter. He often bases his paintings on source material drawn from an ever-growing archive of images that he has culled over the years from family photo albums, magazines, and newspapers. For *Flugzeug II*, one of his earliest prints, Richter re-created a newspaper photograph of an airplane, printing the image off-register and employing a Pop palette of pink and green to make the subject seem poised to shoot off the paper.

103–106 **ANDY WARHOL**

Untitled, Untitled, Untitled, and Untitled from the portfolio *Marilyn Monroe (Marilyn)*. 1967. Screenprints, sheet (each): 36 x 36" (91.5 x 91.5 cm)

Screenprint had long been Warhol's preferred medium when, in 1966, he founded the publishing house Factory Additions (combining the name of his studio and the homonym for "editions") as a means of capitalizing on the American print boom and finding a source of broader distribution for some of his most famous images. The first published portfolio consisted of ten riotous color variations on Marilyn Monroe, including the four shown above.

 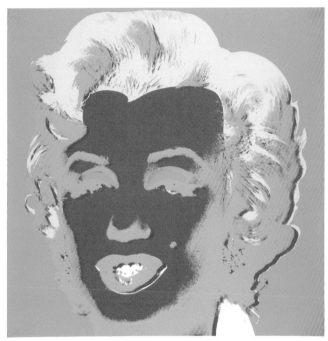

107 MARCEL BROODTHAERS

Museum-Museum. 1972. Screenprint on
two sheets, sheet (each): 33 x 23 ¼"
(83 x 59.1 cm)

108–109 DIETER ROTH

Berlin 1 and *Berlin 2* from the series
Deutsche Städte (German cities). 1970.
Screenprint over lithographs, sheet (each):
23 ⅝ x 33" (60 x 83.8 cm)

One of the true iconoclasts of printmaking
in the twentieth century, Roth challenged
all traditional notions of printmaking,
rejecting standardized editions, sending

slices of greasy cheese and sausage through
the printing press, and layering mediums in
unorthodox ways. For each of the works
shown here, he reproduced an assortment
of picture postcards of Berlin and then
screenprinted a field of ink over the resul-
tant composition, leaving visible only the
repeated silhouette of a famous landmark:
the Victory Column appears in the print on
top, and Brandenburg Gate below.

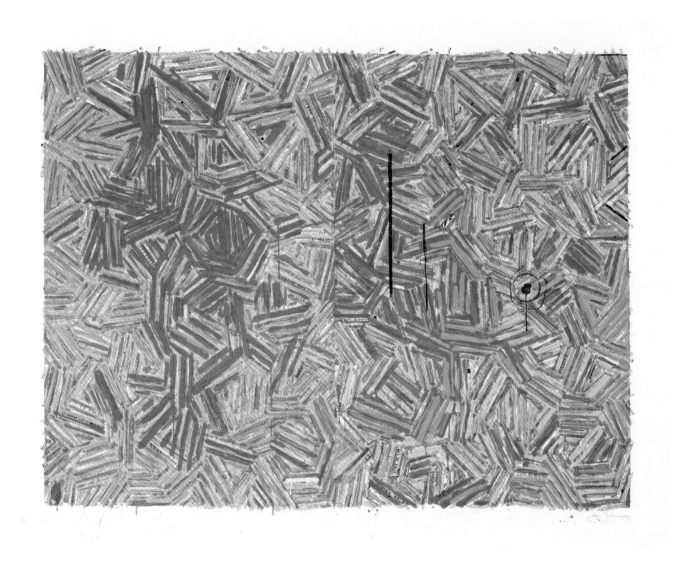

110 JASPER JOHNS

The Dutch Wives. 1977. Screenprint, sheet:
43 ⁷⁄₁₆ x 56 ⅛" (110.3 x 142.6 cm)

111 ROBERT RAUSCHENBERG

Surface Series 54 from the portfolio *Currents*. 1970. Screenprint, sheet: 40 x 40" (101.6 x 101.6 cm)

Printmaking was integral to Rauschenberg's photo-based work, much of which addresses issues of the day, from politics to the environment, through images appropriated from newspapers and other mass-media sources.

Rauschenberg based the eighteen screen-prints in the portfolio *Currents* on newspaper collages he had made that reflect the late 1960s. The prints offer a cacophony of visual information, echoing the omnipresence of the media in contemporary society. Variations on these images appear in a fifty-four-foot-long screenprint, likewise titled *Currents*, made that same year.

¹¹² EUGENIO DITTBORN

8 Sobrevivientes (8 survivors). 1986. Screenprint on folded Kraft paper housed in Kraft paper envelope screenprinted with artist's mailing form and collaged documentation label, sheet (unfolded): 6' 7 ⅞" x 60 ½" (202.9 x 153.7 cm)

For *8 Sobrevivientes*, Dittborn appropriated images from anthropological and archaeo-logical sources, police photographs, and phone-booth doodles and screenprinted them on inexpensive brown wrapping paper. The work was meant to be folded and sent in an accompanying envelope from exhibition to exhibition—offering not only a wry comment on the circulation of artwork but also a means of bypassing censorship when Chile was under military dictatorship.

¹¹³ HANNAH WILKE

Marxism and Art: Beware of Fascist Feminism. 1977. Screenprint on Plexiglas, sheet: 35 ⁷⁄₁₆ x 27 ⅜" (90 x 69.5 cm)

114 ASHLEY BICKERTON

Bad. 1988. Screenprint, sheet: 51 $^{15}\!/_{16}$ x 48"
(132 x 122 cm)

115 PETER HALLEY

Exploding Cell. 1994. Screenprints, sheet (each): 36 ½ x 47 ⅛" (92 x 119.7 cm)

In this grid of nine images, Halley presents a filmic narrative in which a cell (a stand-in for social bodies in postindustrial society)

becomes contaminated past the point of containment, explodes, and is reduced to a pile of dust. Executed in a graphic style, a format that recalls comic strips, and a bright palette, the prints belie the cycle of destruction that they represent.

VE 888/100 "FABRICATED PORTUGAL BRIGHT SKYGEMS" [signature] 2004

116 RYAN McGINNESS

Untitled from the series Fabricated Cultural Belief Systems. 2004. Screenprint, sheet: 39 ¹⁵⁄₁₆ x 26 ³⁄₈" (101.5 x 67 cm)

117 JULIAN OPIE

Elena, schoolgirl (with lotus blossom). 2006. Screenprint, sheet: 20 ¹⁄₁₆ x 15 ⁵⁄₈" (51 x 39.7 cm)

Opie has distributed his images widely across a range of platforms, from printed ephemera such as T-shirts, postage stamps, album covers, and plastic shopping bags

to digital animations and lenticular prints. By rendering his subjects in generalized ways, the artist elevates them to iconic status, as he does in this portrait of his daughter Elena. Opie's bold, reductive compositions, with their areas of unmodulated color, serve as quintessential examples of the screenprint look.

118 CORY ARCANGEL

Monoprint 4. 2008. Screenprint on watermarked paper, sheet: 39 ¾ x 30 ¹⁄₁₆" (101 x 76.3 cm)

Arcangel explores both the new and the newly obsolete technologies of the digital age. Here he looks to screenprint, using his lack of familiarity with the medium as the basis of the project. Printing on specially made paper that bears a large watermark of his name, Arcangel allowed his technical blunders (imperfect registration, uneven inking) to remain in the final image, essentially revealing his hidden signature in a work that questions ideals of artistic virtuosity.

119 SARAH MORRIS

Capital (A Film by Sarah Morris). 2001. Screenprint, sheet: 59 ¾ x 39 ⅞" (151.8 x 101.3 cm)

CAPITAL
A Film by Sarah Morris
Cinematography David Daniel
Music Liam Gillick
Producer Rebecca Siegal
Editor Wilson Converse
Assistant Camera Byron Raney
A Parallax Production ©2000

OTHER PROCESSES AND NEW TECHNOLOGIES

Although a wide range of approaches to printmaking has been discussed thus far, it represents only the tip of what can be considered a massive iceberg. Artists have engaged with printmaking—and its conditions of distribution, collaboration, and reproduction—in myriad other ways as well, often working outside traditional processes and mediums. The examples that follow suggest just a few of these ways.

Some artists start with found printed materials, from newspapers to wallpaper, and make their own prints out of them, or they work with readymade matrices. Léon Ferrari, for example, has incorporated commercial Letraset transfers (widely used in graphic design before the advent of computers) into a conceptual practice. In his *Heliografías* (1980; pl. 121), a series of diazotype blueprints made with light-sensitized paper, Ferrari employed the transfers to build up compositions showing endless traffic loops of tiny cars or labyrinthine office complexes packed with anonymous figures, the works conveying what the artist calls the "architecture of insanity" found in urban life. In the 1960s and '70s, David Hammons used his own body as a stamp to create over five hundred prints (pl. 122), "inking" himself with margarine or oil and then lying

on sheets of paper, sometimes adding powdered pigment or screenprint to the resultant compositions.

Technology has always been an important force in the expansion of printmaking's terms. Just as the offset press revolutionized lithography in the late nineteenth century, allowing images to be printed hundreds of thousands of times, digital technologies have radically altered printmaking over the past three decades. Computer programs including Photoshop and Illustrator enable artists to create, combine, and transform images onscreen and then print them on machines ranging from desktop inkjet printers to carefully calibrated, large-format printers loaded with inks said to be color-fast for hundreds of years. For *Beogram 4000 Hi Fi System* (2002; pl. 125), Kelley Walker digitally layered his own colorful looping imagery on top of a vintage image of a record player. He also includes, with the acquisition of the print, a CD-ROM containing a digital file of the work, inviting owners to modify, reproduce, and disseminate it at any size and on any material they choose. Even as digital technology advances printmaking, the analog remains an important tool. For *Nontransparent Monument* (2006; pl. 127), Cai Guo-Qiang utilized an ancient Chinese technique, ink rubbing, to render moments from the post-9/11 world side-by-side with traditional Chinese decorative motifs.

For the sake of clarity, the preceding chapters have presented printmaking as an assortment of relatively distinct mediums. Artists, however, often use mediums not discretely but in combination with one another. Perhaps there is no better example of such amalgamation than Ellen Gallagher's monumental portfolio *DeLuxe* (2004–05; pl. 132), which brings together the old (intaglio, lithography, and screenprint) and the new (laser cutting, not to mention plasticine and toy eyeballs), serving as perhaps the most adventurous print project of the still-young twenty-first century.

120 PAUL NOBLE

nobnest zed. 2002. Lithographed wallpaper, dimensions variable

Wallpaper offers artists a means of creating an all-encompassing art installation or of translating their work for use in a domestic environment. Noble spent years constructing an invented city called Nobson Newtown, carefully articulating its geography, buildings, and residents in multiple mediums. In *nobnest zed*, the artist depicted surreal and scatalogical moments of town life in brick-shaped vignettes, creating a pattern that, as he envisioned it, would plaster the walls of a bedroom, prompting both dreams and nightmares.

121 LEÓN FERRARI

Cidade (City) from the series *Heliografías* (Blueprints). 1980 (signed 2007). Diazotype, sheet: 38 9/16 x 38 ¾" (98 x 98.5 cm)

122 DAVID HAMMONS

Untitled. 1969. Body print on board, sheet:
35 ¾ x 24 ¹³/₁₆" (90.8 x 63 cm)

123–24 DAN PERJOVSCHI

Balkan Konsulat No Comment in the
newspaper *Der Standard*. 2003. Lithograph,
sheet: 18 ⁵/₁₆ x 12 ⅜" (46.5 x 31.5 cm)

Balkan Konsulat No Comment in the
newspaper *Respekt*. 2003. Lithograph,
sheet: 18 ⁵/₁₆ x 12 ⅜" (46.5 x 31.5 cm)

Redefining the very idea of a museum, the
Vienna-based Museum in Progress maintains
no traditional gallery space and instead inte-
grates art into everyday life by inserting it into
mass-media venues such as magazines and

displaying it on billboards. Dan Perjovschi,
known for his playful but politically incisive
drawings, contributed works that were
printed in two newspapers—*Der Standard* in
Austria and *Respekt* in the Czech Republic.

125 KELLEY WALKER

Beogram 4000 Hi Fi System. 2002. Digital print with CD-ROM, sheet: 20 ⅜ x 29 ³⁄₁₆" (51.7 x 74.2 cm)

126 WILLIE COLE

Domestic I.D. IV. 1992. Steam-iron scorch and pencil on paper in recycled wooden window frame, 35 x 32 x 1 ⅜" (88.9 x 81.3 x 3.5 cm)

The household steam iron figures centrally in Cole's work. In addition to representing the form in sculptures and cut-paper silhouettes, he has employed actual irons in a practice that serves as an extension of printmaking—using the tool as a kind of readymade matrix that imprints paper by scorching it. In such works, including the one shown here, the artist draws out the resemblance between irons—with their connotations of domestic labor—and African tribal masks. The patterns produced by the metal surfaces also suggest human branding or scarification.

¹²⁷ CAI GUO-QIANG

Nontransparent Monument. 2006. Ink rubbings, sheet (each): 69 5/16–100 3/8 x 51 3/16" (176–255 x 130 cm)

This work harkens back to the beginnings of printmaking in ancient China, where ink rubbings were made from stelae, or stone carvings, as a means of transmitting information. Rather than Buddhist sutras or Tang poetry, however, Cai's stelae feature contemporary vignettes—showing same-sex weddings, Abu Ghraib, and the aftermath of Hurricane Katrina, as well as globally recognizable figures like George Bush and Pope John Paul II—alongside traditional decorative motifs of chrysanthemums and plum blossoms.

128–29 **SEHER SHAH**

Untitled and Untitled from the portfolio *The Black Star*. 2007. Digital prints, composition (each): 11 x 19" (27.9 x 48.2 cm)

For the ongoing *Black Star* project, Shah draws on an archive of materials that she has assembled over the years, including intricate spatial renderings; images of tra-

ditional painted miniatures from India or Pakistan, Mughal portraits, and historic architectural sites; and her own snapshots. The artist digitally layers these source materials, reusing and recombining elements in different compositional permutations.

130–31 **PAUL CHAN**

Deadman 2 and *Deadman 4* from the series Deadman 1–5. 2003. Digital prints, sheet (each): 19 x 12 15⁄16" (48.3 x 32.8 cm)

 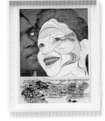 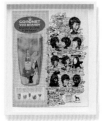 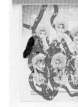

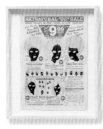

 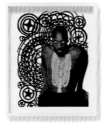

132 ELLEN GALLAGHER

DeLuxe. 2004–05. Photogravure, etching, aquatint, and drypoints with lithography, screenprint, embossing, tattoo-machine engraving, laser cutting, and chine collé; and additions of plasticine, paper collage, enamel, varnish, gouache, pencil, oil, polymer, watercolor, pomade, velvet, glitter, crystals, foil paper, gold leaf, toy eyeballs, and imitation ice cubes, sheet (each): 13 x 10 ½" (33 x 26.7 cm)

DeLuxe is a towering monument to the art of contemporary printmaking, calling on a multitude of techniques from the traditional to the previously untested. Each of the sixty compositions begins with a page appropriated from a vintage issue—dating from the 1930s to the 1970s—of a magazine geared toward an African-American demographic, such as *Sepia* or *Ebony*. Gallagher heavily reworked these pages, layering them with printed elements in a range of mediums and with sundry found materials like pomade and toy googly eyes. Given its experimental and labor-intensive nature, the project would have been difficult to realize were it not for the workshop environment, in which the artist could collaborate with master technicians.

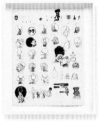
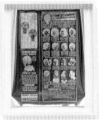
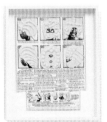
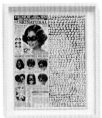

CHECKLIST

JOSEF ALBERS
(American, born Germany. 1888–1976)
Tlaloc. 1944. Woodcut, composition: 12 x
12 ⁷⁄₁₆" (30.5 x 31.6 cm); sheet: 13 ⅞ x 13 ⅝"
(35.3 x 34.6 cm). Publisher: the artist,
Asheville, N.C. Printer: Biltmore Press,
Asheville, N.C. Edition: proof outside the
edition of 35. Gift of Elaine Lustig Cohen
in memory of Alvin Lustig, 1979. (Plate 18)

Aura from *Homage to the Square: Ten Works by
Josef Albers.* 1962. One from a portfolio of ten
screenprints, composition: 11 ¹⁄₁₆ x 11 ¹⁄₁₆" (28.1 x
28.1 cm); sheet: 16 ¹⁵⁄₁₆ x 16 ¹⁵⁄₁₆" (43 x 43 cm).
Publisher: Ives-Sillman, New Haven. Printer:
R. H. Norton Co., New Haven. Edition: 250.
Transferred from the Library Collection to the
Museum Collection, 1993. (Plate 94)

Patina from *Homage to the Square: Ten Works by
Josef Albers.* 1962. One from a portfolio of ten
screenprints, composition: 11 ¹⁄₁₆ x 11 ¹⁄₁₆" (28.1 x
28.1 cm); sheet: 16 ¹⁵⁄₁₆ x 16 ¹⁵⁄₁₆" (43 x 43 cm).
Publisher: Ives-Sillman, New Haven. Printer:
R. H. Norton Co., New Haven. Edition: 250.
Transferred from the Library Collection to the
Museum Collection, 1993. (Plate 93)

SYBIL ANDREWS
(British, 1898–1992)
Racing. 1934. Linoleum cut, composition:
10 ⁵⁄₁₆ x 13 ½" (26.2 x 34.3 cm); sheet: 11 ⅞ x
14 ¹⁵⁄₁₆" (30.2 x 37.9 cm). Publisher and printer:
the artist, London. Edition: 60. Sharon P.
Rockefeller Fund and General Print Fund,
2006. (Plate 12)

CORY ARCANGEL
(American, born 1978)
Monoprint 4. 2008. Screenprint on watermarked
paper, composition: 35 ¹⁄₁₆ x 23 ⅝" (89 x 60 cm);
sheet: 39 ¾ x 30 ¹⁄₁₆" (101 x 76.3 cm).
Publisher: the artist, New York. Printer:
Kayrock Screenprinting, Inc., New York.
Edition: unique. Fund for the Twenty-First
Century, 2009. (Plate 118)

GEORG BASELITZ
(German, born 1938)
Untitled. 1967. Woodcut, composition: 14 ⅛ x
11 ¹³⁄₁₆" (35.9 x 30 cm); sheet: 16 ¹⁄₁₆ x 12 ¹⁵⁄₁₆"
(40.8 x 32.8 cm). Publisher and printer: the
artist, Osthofen, Germany. Edition: 20. Gift of
the Lauder Foundation, 1988. (Plate 22)

CHRISTIANE BAUMGARTNER
(German, born 1967)
Schkeuditz II from Schkeuditz I–IV. 2005. One
from a series of four woodcuts, composition:
16 ⅜ x 24 ⁷⁄₁₆" (41.6 x 62 cm); sheet: 23 ⁷⁄₁₆ x
30 ¹¹⁄₁₆" (59.5 x 78 cm). Publisher and printer:
the artist, Leipzig. Edition: 10. Johanna and
Leslie J. Garfield Fund, 2007. (Plate 28)

Schkeuditz IV from Schkeuditz I–IV. 2005. One
from a series of four woodcuts, composition:
16 ⅜ x 24 ⁷⁄₁₆" (41.6 x 62 cm); sheet: 23 ⁷⁄₁₆ x
30 ¹¹⁄₁₆" (59.5 x 78 cm). Publisher and printer:
the artist, Leipzig. Edition: 10. Johanna and
Leslie J. Garfield Fund, 2007. (Plate 29)

THOMAS BAYRLE
(German, born 1937)
American Dream (Chrysler). 1970. Screenprint,
composition and sheet: 15 ½ x 34" (39.3 x
86.3 cm). Publisher: the artist, Frankfurt.
Printer: Klaus Menzel, Wiesbaden, Germany.
Edition: proof outside the edition of 25. Maud
and Jeffrey Welles Fund, 2010. (Plate 101)

GEORGE BELLOWS
(American, 1882–1925)
Jean. 1923. Lithograph, composition: 9 ⅜ x 7"
(23.7 x 17.8 cm); sheet: 14 ½ x 12 ½" (36.8 x
31.9 cm). Publisher: probably the artist, New
York. Printer: Bolton Brown, New York.
Edition: 58. Gift of Abby Aldrich Rockefeller,
1940. (Plate 74)

ASHLEY BICKERTON
(British, born 1959)
Bad. 1988. Screenprint, composition: 42 ¹¹⁄₁₆ x
40" (108.5 x 101.7 cm); sheet: 51 ¹⁵⁄₁₆ x 48"
(132 x 122 cm). Publisher: Sonnabend
Gallery, Inc., New York. Printer: the artist's
studio, New York. Edition: 20. Purchase,
1989. (Plate 114)

LOUISE BOURGEOIS
(American, born France. 1911–2010)
Plate 7 from *He Disappeared Into Complete
Silence* by Louise Bourgeois. 1947. Engraving
and drypoint from an illustrated book with
nine engravings, three with drypoint, plate:
6 ¹⁵⁄₁₆ x 5 ⁷⁄₁₆" (17.7 x 13.8 cm); sheet: 10 x 6 ¹⁵⁄₁₆"

(25.3 x 17.7 cm). Publisher: Gemor Press, New
York. Printer: the artist at Atelier 17, New York.
Edition: 54 announced; 14 known sets. Abby
Aldrich Rockefeller Fund, 1947. (Plate 45)

MARCEL BROODTHAERS
(Belgian, 1924–1976)
Museum-Museum. 1972. Screenprint on two
sheets, composition: 33 x 46 ½" (83.9 x 118.2
cm); sheet (each): 33 x 23 ¼" (83 x 59.1 cm).
Publisher: Edition Staeck, Heidelberg,
Germany. Printer: Gerhard Steidl, Göttingen,
Germany. Edition: 100. The Associates Fund,
1991. (Plate 107)

CAI GUO-QIANG
(Chinese, born 1957)
Nontransparent Monument. 2006. Set of five ink
rubbings, composition (each): 61 ¹³⁄₁₆–90 ³⁄₁₆ x
46 ⅝–51 ³⁄₁₆" (157–229 x 118.5–130 cm); sheet
(each): 69 ⁵⁄₁₆–100 ⅜ x 51 ³⁄₁₆" (176–255 x
130 cm). Publisher: the artist, New York and
Beijing. Printer: Xinwen Craft Co. Ltd.,
Quanzhou, China. Edition: 20. Stephen F.
Dull Fund, 2007. (Plate 127)

ERNESTO CAIVANO
(Spanish, born 1972)
Knight Interlude II from *Knight Interlude.* 2005.
One from a portfolio of twelve etching and
aquatints, plate: 9 ⅜ x 6 ⅜" (23.8 x 16.2 cm);
sheet: 15 ¹³⁄₁₆ x 12 ⁵⁄₁₆" (40.2 x 31.2 cm).
Publisher and printer: LeRoy Neiman Center
for Print Studies, Columbia University, New
York. Edition: 26. Alexandra Herzan Fund,
2005. (Plate 52)

Knight Interlude IX from *Knight Interlude.* 2005.
One from a portfolio of twelve etching and
aquatints, plate: 9 ⅜ x 6 ⅜" (23.8 x 16.2 cm);
sheet: 15 ¹³⁄₁₆ x 12 ⁵⁄₁₆" (40.2 x 31.2 cm).
Publisher and printer: LeRoy Neiman Center
for Print Studies, Columbia University, New
York. Edition: 26. Alexandra Herzan Fund,
2005. (Plate 53)

ELIZABETH CATLETT
(American, born 1915)
Sharecropper. 1952, published 1968–70.
Linoleum cut, composition: 17 ⅝ x 16 ¹⁵⁄₁₆"
(44.8 x 43 cm); sheet: 18 ½ x 18 ¹⁵⁄₁₆" (47 x
48.1 cm). Publisher: the artist and El Taller de
Gráfica Popular, Mexico City. Printer: the
artist and José Sanchez, Mexico City. Edition:
proof outside the edition of 60. The Ralph E.
Shikes Fund and Purchase, 2003. (Plate 17)

PAUL CHAN
(Chinese, born Hong Kong 1973)
Deadman 2 from Deadman 1–5. 2003. One from a series of five digital prints, composition: 10 ¹¹/₁₆ x 10 ⁹/₁₆" (27.2 x 26.8 cm); sheet: 19 x 12 ¹⁵/₁₆" (48.3 x 32.8 cm). Publisher: the artist and Greene Naftali, New York. Printer: Silicon Gallery Fine Art Prints Ltd., Philadelphia. Edition: 5. Harvey S. Shipley Miller Fund, 2004. (Plate 130)

Deadman 4 from Deadman 1–5. 2003. One from a series of five digital prints, composition: 10 ¹⁵/₁₆ x 10 ⁹/₁₆" (27.8 x 26.8 cm); sheet: 19 x 12 ¹⁵/₁₆" (48.3 x 32.8 cm). Publisher: the artist and Greene Naftali, New York. Printer: Silicon Gallery Fine Art Prints Ltd., Philadelphia. Edition: 5. Harvey S. Shipley Miller Fund, 2004. (Plate 131)

CHUCK CLOSE
(American, born 1940)
Lucas/Woodcut. 1993. Woodcut and pochoir, composition: 36 x 30" (91.4 x 76.2 cm); sheet: 46 ¼ x 36" (117.5 x 91.4 cm). Publisher: Pace Editions, New York. Printer: Karl Hecksher, New York. Edition: 50. Gift of Anna Marie and Robert F. Shapiro in honor of Robert Storr and Deborah Wye, 1998. (Plate 31)

WILLIE COLE
(American, born 1955)
Domestic I.D. IV. 1992. Steam-iron scorch and pencil on paper in recycled wooden window frame, 35 x 32 x 1 ⅜" (88.9 x 81.3 x 3.5 cm). Edition: unique. Acquired through the generosity of Agnes Gund, 1994. (Plate 126)

RALSTON CRAWFORD
(American, born Canada. 1906–1978)
Red and Black (U.S.S. Nevada). 1949. Screenprint, composition: 12 ⁵/₁₆ x 16" (31.3 x 40.6 cm); sheet: 17 ³/₁₆ x 23 ⅜" (43.7 x 59.4 cm). Publisher and printer: unknown. Edition: unknown. Gift of Mrs. Edith Gregor Halpert, 1949. (Plate 91)

STUART DAVIS
(American, 1892–1964)
Barber Shop Chord. 1931. Lithograph, composition: 14 x 19" (35.5 x 48.2 cm); sheet: 17 ¼ x 21 ⅝" (43.8 x 54.9 cm). Publisher: probably the artist, New York. Printer: probably George C. Miller, New York. Edition: 25. Gift of Abby Aldrich Rockefeller, 1940. (Plate 69)

WILLEM DE KOONING
(American, born the Netherlands. 1904–1997)
Litho # 2 (Waves # 2). 1960. Lithograph, composition: 42 ¹¹/₁₆ x 30 ¾" (108.5 x 78.1 cm); sheet: 45 ⅞ x 31 ¾" (116.6 x 80.7 cm). Publisher: the artist, Berkeley, Calif. Printer: Nathan Olivera and George Miyasaki at the University of California, Berkeley. Edition: 9. Gift of Mrs. Bliss Parkinson, 1964. (Plate 77)

EUGENIO DITTBORN
(Chilean, born 1943)
8 Sobrevivientes (8 survivors). 1986. Screenprint on folded Kraft paper housed in Kraft paper envelope screenprinted with artist's mailing form and collaged documentation label, sheet (unfolded): 6' 7 ⅞" x 60 ½" (202.9 x 153.7 cm); envelope: 20 ¹¹/₁₆ x 15 ¹⁵/₁₆" (52 x 40.5 cm). Publisher: unpublished. Printer: Impresos Punto Color Limitada, Santiago, Chile. Edition: 4 variants. Purchase, 1986. (Plate 112)

JEAN DUBUFFET
(French, 1901–1985)
Angle de mur à l'oiseau perché (Bird perched on the corner of the wall) from *Les Murs* (Walls) by Eugène Guillevic. 1945. One from an illustrated book of fifteen lithographs, composition and sheet: 14 ⅜ x 11" (36.5 x 27.9 cm). Publisher: Joseph Zichieri, Paris. Printer: Mourlot, Paris. Edition: 20. Gift of Mr. and Mrs. Ralph F. Colin, 1965. (Plate 78)

JAMES ENSOR
(Belgian, 1860–1949)
Les Gendarmes, state VI. 1888. Etching with gouache additions, plate: 7 x 9 ⅜" (17.8 x 23.8 cm); sheet: 13 ¹¹/₁₆ x 18 ¾" (34 x 47.6 cm). Publisher: the artist, Ostend, Belgium. Printer: probably Jean-Baptiste van Campenhout, Brussels. Edition: unknown. The Ralph E. Shikes Fund and Purchase, 1998. (Plate 35)

LYONEL FEININGER
(American, 1871–1956)
Woodblock for *Fischerboote* (Fishing boats). 1918. 4 ⅞ x 6 ⅜ x ⅜" (12.4 x 16.2 x 0.9 cm). Gift of Julia Feininger, 1966. (Plate 10)

Fischerboote (Fishing boats). 1918. Woodcut, composition: 4 ¹⁵/₁₆ x 6 ½" (12.6 x 16.5 cm); sheet: 8 ⁹/₁₆ x 11" (21.8 x 27.9 cm). Publisher: unpublished. Printer: the artist, New York. Edition: approx. 6–15 . Gift of the artist and his wife, Julia Feininger, 1955. (Plate 10)

LEÓN FERRARI
(Argentine, born 1920)
Cidade (City) from *Heliografías* (Blueprints). 1980 (signed 2007). One from a series of twenty-seven diazotypes, composition: 37 ⅜ x 37 ⅝" (95 x 95.5 cm); sheet: 38 ⁹/₁₆ x 38 ¾" (98 x 98.5 cm). Publisher and printer: the artist, São Paulo. Edition: unlimited. Gift of the artist, 2007. (Plate 121)

CLAUDE FLIGHT
(British, 1881–1955)
Brooklands. c. 1929. Linoleum cut, composition: 11 ¹⁵/₁₆ x 10 ¹/₁₆" (30.3 x 25.5 cm); sheet: 13 ⁷/₁₆ x 11 ¼" (34.2 x 28.5 cm). Publisher and printer: the artist, London. Edition: 50. Edward John Noble Foundation Fund, Philip and Lynn Straus Foundation Fund, Miles O. Epstein Fund, Richard A. Epstein Fund, and Sarah C. Epstein Fund, 2003. (Plate 13)

SAM FRANCIS
(American, 1923–1994)
The Upper Yellow. 1960. Lithograph, composition and sheet: 24 ⅞ x 35 ¹¹/₁₆" (63.2 x 90.6 cm). Publisher: Kornfeld and Klipstein, Bern, Switzerland. Printer: Emil Matthieu Atelier, Zurich. Edition: 65. D. S. and R. H. Gottesman Foundation Fund, 1963. (Plate 76)

HELEN FRANKENTHALER
(American, born 1928)
Cedar Hill. 1983. Woodcut, composition and sheet: 20 ⁷/₁₆ x 25 ⅛" (51.9 x 63.8 cm). Publisher: Crown Point Press, San Francisco. Printer: Shi-un-do Print Shop, Kyoto, Japan. Edition: 75. Gift of Crown Point Press in celebration of its 25th anniversary, 1987. (Plate 24)

LUCIAN FREUD
(British, born Germany. 1922–2011)
Copper plate for *Head of an Irishman.* 1999. 29 ⁵/₁₆ x 22 ⁵/₁₆" (74.5 x 56.6 cm). Gift of the artist and Marc Balakjian, Studio Prints, 2007. (Plate 48)

Head of an Irishman. 1999. Etching, plate: 29 ¼ x 22 ¼" (74.3 x 56.5 cm); sheet: 38 ¼ x 30 ¾" (97.2 x 78.1 cm). Publisher: Matthew Marks Gallery, New York. Printer: Marc Balakjian, Studio Prints, London. Edition: 46. Monroe Wheeler Fund, 2007. (Plate 48)

ELLEN GALLAGHER
(American, born 1965)
DeLuxe. 2004–05. Portfolio of sixty photogravure, etching, aquatint, and drypoints with lithography, screenprint, embossing, tattoo-machine engraving, laser cutting, and chine collé; and additions of plasticine, paper collage, enamel, varnish, gouache, pencil, oil, polymer, watercolor, pomade, velvet, glitter, crystals, foil paper, gold leaf, toy eyeballs, and imitation ice cubes, sheet (each): 13 x 10 ½" (33 x 26.7 cm). Publisher and printer: Two Palms Press, New York. Edition: 20. Acquired through the generosity of The Friends of Education of The Museum of Modern Art and The Speyer Family Foundation, Inc., with additional support from the General Print Fund, 2004. (Plate 132)

PAUL GAUGUIN
(French, 1848–1903)
Nave Nave Fenua (Fragrant isle) from *Noa Noa* (Fragrance). 1893–94. One from a series of ten woodcuts, composition: 14 x 8 ¹⁄₁₆" (35.5 x 20.5 cm); sheet: 15 ¹¹⁄₁₆ x 9 ¹³⁄₁₆" (39.9 x 24.9 cm). Publisher: the artist, Paris. Printer: Louis Roy, Paris. Edition: 25–30. Gift of Abby Aldrich Rockefeller, 1940. (Plate 2)

Noa Noa (Fragrance) from *Noa Noa* (Fragrance). 1893–94. One from a series of ten woodcuts, composition: 14 x 8 ¹⁄₁₆" (35.5 x 20.5 cm); sheet: 15 ½ x 9 ⅝" (39.3 x 24.4 cm). Publisher: the artist, Paris. Printer: Louis Roy, Paris. Edition: 25–30. Lillie P. Bliss Collection, 1934. (Plate 1)

GEGO
(Gertrud Goldschmidt; Venezuelan, born Germany. 1912–1994)
Balance. 1960. Etching, plate: 9 ¹³⁄₁₆ x 8 ¾" (25 x 22.2 cm); sheet: 14 ¹⁵⁄₁₆ x 11 ⅛" (38 x 28.3 cm). Publisher and printer: the artist, Caracas. Edition: 10. Inter-American Fund, 1967. (Plate 47)

ROBERT GOBER
(American, born 1954)
Untitled. 2002. Lithograph, composition: 47 ¼ x 31 ¹⁵⁄₁₆" (120 x 81.2 cm); sheet: 51 ¹⁄₁₆ x 36 ¹⁄₁₆" (129.7 x 91.6 cm). Publisher and printer: Gemini G.E.L., Los Angeles. Edition: 65. John B. Turner Fund, 2002. (Plate 89)

NATALIA GONCHAROVA
(Russian, 1881–1962)
Angely i aeroplany (Angels and airplanes) from *Misticheskie obrazy voiny. 14 litografii* (Mystical images of war. 14 lithographs). 1914. One from a portfolio of fourteen lithographs, composition: 12 ¹⁄₁₆ x 8 ¹⁵⁄₁₆" (30.6 x 22.7 cm); sheet: 12 ⅞ x 9 ⁷⁄₁₆" (32.7 x 24 cm). Publisher: V. N. Kashin, Moscow. Printer: unknown. Edition: unknown. Gift of The Judith Rothschild Foundation, 2001. (Plate 68)

PHILIP GUSTON
(American, born Canada. 1913–1980)
Curtain. 1980, published 1981. Lithograph, composition: 29 ¾ x 40 ³⁄₁₆" (75.5 x 102 cm); sheet: 30 ¹¹⁄₁₆ x 40 ¾" (77.9 x 103.5 cm). Publisher and printer: Gemini G.E.L., Los Angeles. Edition: 50. Gift of Edward R. Broida, 2005. (Plate 84)

PETER HALLEY
(American, born 1953)
Exploding Cell. 1994. Set of nine screenprints, composition and sheet (each): 36 ½ x 47 ⅛" (92 x 119.7 cm). Publisher: Edition Schellmann, New York. Printer: Heinrici Silkscreen, New York. Edition: 32. Gift of the artist, 1996. (Plate 115)

RICHARD HAMILTON
(British, born 1922)
Adonis in Y Fronts. 1963. Screenprint, composition: 23 ¾ x 32" (60.3 x 81.3 cm); sheet: 26 ½ x 33 ⁵⁄₁₆" (67.3 x 84.6 cm). Publisher: the artist, London. Printer: the artist and Kelpra Studio, London. Edition: 40. Roxanne H. Frank Fund and Ann and Lee Fensterstock Fund, 2004. (Plate 96)

DAVID HAMMONS
(American, born 1943)
Untitled. 1969. Body print on board, composition: 29 ¹⁵⁄₁₆ x 19 ⅛" (76 x 48.5 cm); sheet: 35 ¾ x 24 ¹³⁄₁₆" (90.8 x 63 cm). Printer: the artist, Los Angeles. Edition: unique. The Friends of Education of The Museum of Modern Art, the General Print Fund, and Committee on Drawings Funds, 2009. (Plate 122)

ZARINA HASHMI
(American, born India 1937)
Home Is a Foreign Place. 1999. Portfolio of thirty-six woodcuts and letterpress, mounted on paper, composition (each): 8 x 6" (20.3 x 15.2 cm); sheet (each): 16 x 13" (40.7 x 33 cm). Publisher and printer: the artist, New York. Edition: 25. Acquired through the generosity of Marie-Josée and Henry R. Kravis in honor of Edgar Wachenheim III, 2009. (Plate 27)

ERICH HECKEL
(German, 1883–1970)
Fränzi liegend (Fränzi reclining). 1910. Woodcut, composition: 8 ¹⁵⁄₁₆ x 16 ½" (22.7 x 41.9 cm); sheet: 14 x 21 ⅞" (35.6 x 55.5 cm). Publisher: unpublished. Printer: the artist. Edition: approx. 30–50. Gift of Mr. and Mrs. Otto Gerson, 1958. (Plate 8)

DAVID HOCKNEY
(British, born 1937)
Lithograph of Water Made of Thick and Thin Lines, a Green Wash, a Light Blue Wash, and a Dark Blue Wash. 1978–80. Lithograph, composition: 20 ¹⁄₁₆ x 27 ³⁄₁₆" (51 x 69 cm); sheet: 26 x 34 ½" (66 x 87.6 cm). Publisher and printer: Tyler Graphics Ltd., Bedford, N.Y. Edition: 80. Eugene Mercy, Jr. Fund, 2005. (Plate 82)

JASPER JOHNS
(American, born 1930)
Stone from the portfolios *0–9 (Black)*, *0–9 (Color)*, and *0–9 (Gray)*. 1960–63. Lithographic stone, inked in white and varnished, 18 x 14 x 2 ¾" (45.7 x 35 x 7 cm). Gift of Mrs. Tatyana Grosman, 1963. (Plate 75)

9 from *0–9 (Gray)*. 1963. One from a portfolio of ten lithographs, composition: 15 ⅞ x 12 ⅛" (40.3 x 30.8 cm); sheet: 20 ¼ x 15 ⅞" (51.5 x 40.3 cm). Publisher and printer: Universal Limited Art Editions, West Islip, N.Y. Edition: 10. Gift of the Celeste and Armand Bartos Foundation, 1964. (Plate 75)

The Dutch Wives. 1977. Screenprint, composition: 40 ½ x 50 ⅛" (102.8 x 127.3 cm); sheet: 43 ⁷⁄₁₆ x 56 ⅛" (110.3 x 142.6 cm). Publisher and printer: Simca Print Artists, New York. Edition: 70. Elizabeth Bliss Parkinson Fund, Blanchette Hooker Rockefeller Fund, Joanne M. Stern Fund, and Jeanne C. Thayer Fund, 1978. (Plate 110)

WILLIAM H. JOHNSON
(American, 1901–1970)
Blind Singer. c. 1940. Screenprint with tempera additions, composition and sheet: 17 ½ x 11 ½" (44.5 x 29.2 cm). Publisher: unpublished. Printer: the artist. Edition: unknown. Riva Castleman Endowment Fund and the Friends of Education Fund, 2001. (Plate 92)

DONALD JUDD
(American, 1928–1994)
Untitled (7-L). 1968. Painted woodblock, 25 ¹¹⁄₁₆ x 15 ⅞ x 1 ¹⁵⁄₁₆" (65.2 x 40.3 x 4.9 cm).

John B. Turner Fund, Lily Auchincloss Fund, Roxann Taylor Fund, Carol and Morton Rapp Fund, and Stephen F. Dull Fund, 2008. (Plate 21)

Untitled (7-L) from Untitled. 1968–69 (series begun in 1963). One from a series of twenty-six woodcuts, composition: 25 9/16 x 15 7/8" (65 x 40.3 cm); sheet: 30 5/8 x 22" (77.8 x 55.9 cm). Publisher: the artist, New York. Printer: Roy C. Judd, Ramsey, N.J. Edition: 32. Eugene Mercy, Jr. Fund and Marnie Pillsbury Fund, 2008. (Plate 20)

ELLSWORTH KELLY
(American, born 1923)
Red Over Yellow from Suite of Twenty-Seven Color Lithographs. 1964–65. One from a series of twenty-seven lithographs, composition: 22 7/16 x 15 9/16" (57 x 39.5 cm); sheet: 35 1/4 x 23 1/2" (89.5 x 59.7 cm). Publisher: Maeght Éditeur, Paris. Printer: Maeght Imprimerie, Levallois-Perret, France. Edition: 75. Given anonymously, 1965. (Plate 79)

PAUL KLEE
(German, born Switzerland. 1879–1940)
Drohendes Haupt (Menacing head) from *Inventionen* (Inventions). 1905. One from a series of twelve etchings, plate: 7 11/16 x 5 3/4" (19.6 x 14.6 cm); sheet: 15 13/16 x 12" (40.2 x 30.5 cm). Publisher: the artist, Bern, Switzerland. Printer: Max Girardet, Bern, Switzerland. Edition: approx. 16. Purchase, 1941. (Plate 34)

KÄTHE KOLLWITZ
(German, 1867–1945)
Die Freiwilligen (The volunteers) from *Krieg* (War). 1921–22, published 1923. One from a portfolio of seven woodcuts, composition: 13 3/4 x 19 1/2" (34.9 x 49.5 cm); sheet: 18 11/16 x 25 3/4" (47.5 x 65.4 cm). Publisher: Emil Richter, Dresden, Germany. Printer: probably Fritz Voigt, Berlin. Edition: 100. Gift of the Arnhold Family in memory of Sigrid Edwards, 1992. (Plate 11)

YAYOI KUSAMA
(Japanese, born 1929)
Endless. 1953–84. Etching, plate: 10 11/16 x 17 9/16" (27.1 x 44.6 cm); sheet: 17 11/16 x 24 3/4" (45 x 62.8 cm). Publisher: Fuji Television Gallery Co., Ltd., Tokyo. Printer: Kihachi Kimura, Tokyo. Edition: 30. Gift of Jeff Rothstein and Reiko Tomii in memory of Bhupendra Karia, 1999. (Plate 46)

SHERRIE LEVINE
(American, born 1947)
Meltdown. 1989. Portfolio of four woodcuts, composition: 23 5/8 x 18" (60 x 45.8 cm); sheet 36 3/4 x 25 3/4" (93 x 65.4 cm). Publisher: Peter Blum Edition, New York. Printer: Derrière L'Étoile Studios, New York. Edition: 35. Brook and Roger S. Berlind Fund, 1989. (Plate 26)

ROY LICHTENSTEIN
(American, 1923–1997)
Sweet Dreams, Baby! from *11 Pop Artists*, volume III. 1965 (published 1966). One from a portfolio of eleven screenprints by various artists, composition: 35 5/8 x 25 9/16" (90.5 x 65 cm); sheet: 37 11/16 x 27 5/8" (95.7 x 70.2 cm). Publisher: Original Editions, New York. Printer: Knickerbocker Machine & Foundry Inc., New York. Edition: 200. Gift of Original Editions, 1966. (Plate 97)

GLENN LIGON
(American, born 1960)
Untitled from *Runaways.* 1993. One from a portfolio of ten lithographs, composition: 10 1/16 x 8 15/16" (25.6 x 22.7 cm); sheet: 16 x 12" (40.7 x 30.5 cm). Publisher: Max Protetch Gallery, New York. Printer: Burnet Editions, New York. Edition: 45. The Ralph E. Shikes Fund, 1993. (Plate 85)

Untitled from *Runaways.* 1993. One from a portfolio of ten lithographs, composition: 10 1/16 x 8 15/16" (25.6 x 22.7 cm); sheet: 16 x 12" (40.7 x 30.5 cm). Publisher: Max Protetch Gallery, New York. Printer: Burnet Editions, New York. Edition: 45. The Ralph E. Shikes Fund, 1993. (Plate 86)

EL LISSITZKY
(Russian, 1890–1941)
Untitled from *Proun.* 1919–23. One lithograph with collage additions from a portfolio of six lithographs, two with collage additions, composition: 18 13/16 x 9 5/8" (47.8 x 24.5 cm); sheet: 23 3/4 x 17 3/8" (60.3 x 44.1 cm). Publisher: Kestner Gesellschaft (Ludwig Ey), Hannover. Printer: Robert Leunis & Chapman, Hannover. Edition: 50. Purchase, 1935. (Plate 67)

JOHN MARIN
(American, 1870–1953)
Woolworth Building (The Dance). 1913. Etching, plate: 13 1/16 x 10 5/8" (33.2 x 27 cm); sheet: 16 9/16 x 13 7/8" (42 x 35.3 cm). Publisher: Alfred Stieglitz at 291, New York. Printer: the artist, New York. Edition: approx. 30. Purchase, 1955. (Plate 38)

BARRY McGEE
(American, born 1966)
Untitled from *Drypoint on Acid.* 2006. Etching and aquatint with chine collé and collaged screenprint additions from a portfolio of four drypoints with chine collé, three drypoints with chine collé and collage additions, one drypoint and aquatint with chine collé and collage additions, one etching with chine collé and spraypaint additions, and one etching and aquatint with chine collé and collaged screenprint additions, composition and sheet: 7 13/16 x 6 3/8" (19.8 x 16.2 cm). Publisher and printer: Edition Jacob Samuel, Santa Monica, Calif. Edition: 20. Ann and Lee Fensterstock Fund, 2006. (Plate 61)

Untitled from *Drypoint on Acid.* 2006. Drypoint with chine collé from a portfolio of four drypoints with chine collé, three drypoints with chine collé and collage additions, one drypoint and aquatint with chine collé and collage additions, one etching with chine collé and spraypaint additions, and one etching and aquatint with chine collé and collaged screenprint additions, composition and sheet: 7 15/16 x 6 7/16" (20.1 x 16.4 cm). Publisher and printer: Edition Jacob Samuel, Santa Monica, Calif. Edition: 20. Ann and Lee Fensterstock Fund, 2006. (Plate 62)

RYAN McGINNESS
(American, born 1972)
Untitled from Fabricated Cultural Belief Systems. 2004. One from a series of one hundred screenprints, composition: 29 1/8 x 25 3/8" (74 x 64.5 cm); sheet: 39 15/16 x 26 3/8" (101.5 x 67 cm). Publisher: unpublished. Printer: the artist, New York. Edition: 100 unique variants. Fund for the Twenty-First Century, 2005. (Plate 116)

LUCY McKENZIE
(British, born 1977)
Aesthetic Integration Scotland. 2001. Linoleum cut with banknote collage addition, composition: 12 1/16 x 8" (30.6 x 20.3 cm); sheet: 16 9/16 x 11 11/16" (42 x 29.7 cm). Publisher and printer: the artist, Glasgow. Edition: unlimited. Fund for the Twenty-First Century, 2007. (Plate 30)

JULIE MEHRETU
(American, born Ethiopia 1970)
Refuge. 2007. Etching and aquatint, plate: 15 3/4 x 19 1/2" (40 x 49.5 cm); sheet: 23 1/4 x 27 15/16" (59.1 x 71 cm). Publisher and printer: Burnet Editions, New York. Edition: 45. Eugene Mercy, Jr. Fund, 2009. (Plate 59)

LEOPOLDO MÉNDEZ
(Mexican, 1902–1969)
La Piñata Política (Political piñata). 1935.
Linoleum cut, composition: 11 ⁷⁄₁₆ x 8 ¾"
(29 x 22.3 cm); sheet: 18 ¹¹⁄₁₆ x 13 ¾" (47.5 x
35 cm). Publisher and printer: probably the
artist, Mexico City. Edition: unknown.
Inter-American Fund, 1944. (Plate 14)

JOAN MIRÓ
(Spanish, 1893–1983)
Plate 4 from *Série noire et rouge* (Black and red
series). 1938. One from a series of eight
etchings, plate: 6 ⅝ x 10 ³⁄₁₆" (16.9 x 25.8 cm);
sheet: 12 ¹³⁄₁₆ x 17 ⅜" (32.6 x 44.1 cm).
Publisher: Pierre Matisse and Pierre Loeb,
Paris. Printer: the artist at Louis Marcoussis's
studio, Paris, and Atelier Lacourière, Paris.
Edition: 30. Purchased with the Frances
Keech Fund and funds given by Agnes Gund
and Daniel Shapiro, Gilbert Kaplan, Jeanne C.
Thayer, Reba and Dave Williams, Ann and Lee
Fensterstock, Linda Barth Goldstein, Walter
Bareiss, Mrs. Melville Wakeman Hall, Emily
Rauh Pulitzer, and Mr. and Mrs. Herbert D.
Schimmel, 1996. (Plate 41)

Plate 5 from *Série noire et rouge* (Black and red
series). 1938. One from a series of eight
etchings, plate: 6 ⅝ x 10 ³⁄₁₆" (16.9 x 25.8 cm);
sheet: 12 ¹³⁄₁₆ x 17 ⅜" (32.6 x 44.1 cm).
Publisher: Pierre Matisse and Pierre Loeb,
Paris. Printer: the artist at Louis Marcoussis's
studio, Paris, and Atelier Lacourière, Paris.
Edition: 30. Purchased with the Frances
Keech Fund and funds given by Agnes Gund
and Daniel Shapiro, Gilbert Kaplan, Jeanne C.
Thayer, Reba and Dave Williams, Ann and Lee
Fensterstock, Linda Barth Goldstein, Walter
Bareiss, Mrs. Melville Wakeman Hall, Emily
Rauh Pulitzer, and Mr. and Mrs. Herbert D.
Schimmel, 1996. (Plate 42)

SARAH MORRIS
(American, born 1967)
Capital (A Film by Sarah Morris). 2001.
Screenprint, composition: 58 ¼ x 38 ⅞"
(148 x 98.7 cm); sheet: 59 ¾ x 39 ⅞" (151.8 x
101.3 cm). Publisher: Parkett Publishers,
Zurich and New York. Printer: Coriander
Studio Ltd., London. Edition: 70. Alexandra
Herzan Fund, 2001. (Plate 119)

EDVARD MUNCH
(Norwegian, 1863–1944)
Angst (Anxiety). 1896. Lithograph, composition:
16 ⁵⁄₁₆ x 15 ⅜" (41.4 x 39.1 cm); sheet: 22 ½ x
16 ¹⁵⁄₁₆" (57.1 x 43.1 cm). Publisher: Ambroise

Vollard, Paris. Printer: Auguste Clot, Paris.
Edition: 100. Abby Aldrich Rockefeller Fund,
1940. (Plate 65)

Kyss IV (Kiss IV). 1897–1902. Woodcut,
composition: 18 ⅜ x 18 ¼" (46.7 x 46.4 cm);
sheet: 24 x 23 ⅝" (61 x 60 cm). Publisher: the
artist. Printer: M. W. Lassally, Berlin, or the
artist. Edition: 50–100 in several color and
compositional variations. Gift of Abby Aldrich
Rockefeller, 1942. (Plate 3)

ELIZABETH MURRAY
(American, 1940–2007)
States I–V. 1980. Set of five lithographs,
composition (each): 19 ⁹⁄₁₆ x 15 ¾" (49.7 x 40
cm); sheet (each): 22 ¹⁄₁₆ x 17 ¹⁵⁄₁₆" (56 x 45.5
cm). Publisher: Paula Cooper Gallery and
Brooke Alexander, Inc., New York. Printer:
Derrière L'Étoile Studios, New York. Edition:
35. Gift of Brooke and Carolyn Alexander,
1994. (Plate 83)

PAUL NOBLE
(British, born 1963)
nobnest zed. 2002. Lithographed wallpaper,
dimensions variable. Publisher: nest, New York.
Printer: Coral Graphics Services, Hicksville,
N.Y. Edition: mass-produced. Linda Barth
Goldstein Fund, 2003. (Plate 120)

EMIL NOLDE
(German, 1867–1956)
Dampfer (gr. dkl.) (Steamer [large, dark]).
1910. Etching, plate: 11 ⅞ x 15 ⅞" (30.2 x 40.4
cm); sheet: 19 ³⁄₁₆ x 22 ¹¹⁄₁₆" (48.7 x 57.7 cm).
Publisher: unpublished. Printer: Carl Sabo,
Berlin. Edition: at least 30. Riva Castleman
Fund, 2005. (Plate 39)

Prophet. 1912. Woodcut, composition: 12 ⅝ x
8 ¾" (32.1 x 22.2 cm); sheet: 19 ¹¹⁄₁₆ x 14 ⅜"
(50 x 36.5 cm). Publisher: unpublished. Printer:
the artist and his wife, Ada Nolde, Berlin.
Edition: approx. 20–30. Given anonymously
(by exchange), 1956. (Plate 9)

SHAUN O'DELL
(American, born 1968)
Beyond When the Golden Portal Can Come. 2005.
Aquatint and etching, plate: 25 ¹³⁄₁₆ x 22 ⅝"
(65.5 x 57.5 cm); sheet: 34 ½ x 29 ½" (87.6 x
74.9 cm). Publisher and printer: Paulson
Press, Berkeley, Calif. Edition: 25. John B.
Turner Fund, 2007. (Plate 58)

JULIAN OPIE
(British, born 1958)
Elena, schoolgirl (with lotus blossom). 2006.
Screenprint, composition: 18 ⅛ x 14 ⅛" (46.1 x
35.8 cm); sheet: 20 ¹⁄₁₆ x 15 ⅝" (51 x 39.7 cm).
Publisher: the artist, London. Printer: Advanced
Graphics, London. Edition: 100. Gift of Sue
and Edgar Wachenheim III, 2006. (Plate 117)

LYGIA PAPE
(Brazilian, 1937–2004)
Untitled. 1959. Woodcut, composition and
sheet: 19 ½ x 19 ½" (49.5 x 49.5 cm).
Publisher and printer: the artist, Rio de
Janeiro. Edition: 4. Gift of Patricia Phelps de
Cisneros in memory of Marcantonio Vilaça,
2000. (Plate 19)

DAN PERJOVSCHI
(Romanian, born 1961)
Balkan Konsulat No Comment in *Der Standard*.
2003. Lithograph printed in newspaper,
composition: 7 ½ x 10 ⁵⁄₁₆" (19 x 26.2 cm);
sheet: 18 ⁵⁄₁₆ x 12 ⅜" (46.5 x 31.5 cm).
Publisher: Museum in Progress, Vienna. Linda
Barth Goldstein Fund, 2006. (Plate 123)

Balkan Konsulat No Comment in *Respekt*. 2003.
Lithograph printed in newspaper, composition:
15 ¹¹⁄₁₆ x 10 ⅝ in (39.8 x 27 cm); sheet: 18 ⁵⁄₁₆ x
12 ⅜" (46.5 x 31.5 cm). Publisher: Museum in
Progress, Vienna. Linda Barth Goldstein
Fund, 2006. (Plate 124)

ELIZABETH PEYTON
(American, born 1965)
Rirkrit Reading. 2002. Etching, plate: 9 ¹³⁄₁₆ x
7 ⅞" (25 x 20 cm); sheet: 17 ⅛ x 14 ³⁄₁₆" (43.5 x
36 cm). Publisher and printer: Two Palms
Press, New York. Edition: 20. Donald B.
Marron Fund, 2002. (Plate 60)

PABLO PICASSO
(Spanish, 1881–1973)
Portrait d'Olga au col de fourrure (Portrait of
Olga in a fur collar). 1923, printed 1955.
Drypoint, plate: 19 ½ x 19 ⁷⁄₁₆" (49.5 x 49.3
cm); sheet: 30 ¹⁄₁₆ x 22 ¼" (76.3 x 56.5 cm).
Publisher: unpublished. Printer: Lacourière,
Paris. Edition: approx. 7 proofs of this state.
Sue and Edgar Wachenheim III Fund; General
Print Fund; Jerry I. Speyer in honor of Edgar
Wachenheim III; Agnes Gund; Nelson Blitz,
Jr. with Catherine Woodard and Perri and
Allison Blitz, in honor of Riva Castleman's
80th birthday; Mary M. and Sash A. Spencer;
The Orentreich Family Foundation in honor of
Deborah Wye; Linda Barth Goldstein in honor

of Deborah Wye; Sharon Percy Rockefeller; Maud and Jeffrey Welles in honor of Deborah Wye; and Roxanne H. Frank, 2010. (Plate 36)

Le taureau (Bull), state III. December 12, 1945. Lithograph, composition: 12 ⅝ x 17" (32.1 x 43.2 cm); sheet: 13 ¹/₁₆ x 17" (33.2 x 43.2 cm). Publisher: unpublished. Printer: Mourlot, Paris. Edition: outside the edition of 18 proofs. Mrs. Gilbert W. Chapman Fund, 1979. (Plate 70)

Le taureau (Bull), state VII. December 26, 1945. Lithograph, composition: 12 x 17 ½" (30.5 x 44.4 cm); sheet: 12 ¹⁵/₁₆ x 17 ½" (32.8 x 44.4 cm). Publisher: unpublished. Printer: Mourlot, Paris. Edition: outside the edition of 18 proofs. Mrs. Gilbert W. Chapman Fund, 1979. (Plate 71)

Le taureau (Bull), state XIV. January 17, 1946. Lithograph, composition: 11 ½ x 15 ¹⁵/₁₆" (29.2 x 40.5 cm); sheet: 13 ¹/₁₆ x 17 ½" (33.2 x 44.4 cm). Publisher: Galerie Louise Leiris, Paris. Printer: Mourlot, Paris. Edition: 50. Acquired through the Lillie P. Bliss Bequest, 1947. (Plate 72)

Profil de Jacqueline au foulard (Profile of Jacqueline with a scarf). 1955. Linoleum cut, composition: 21 ¾ x 19 ¾" (55.2 x 50.2 cm); sheet: 26 ⅜ x 19 ¾" (67 x 50.2 cm). Publisher: unpublished. Printer: Arnéra, Vallauris, France. Edition: approx. 8 proofs. Acquired through the generosity of Mrs. Edmond J. Safra and the General Print Fund, 2003. (Plate 16)

JACKSON POLLOCK
(American, 1912–1956)
Untitled (4). 1944–45. Engraving and dry-point, plate: 14 ¹⁵/₁₆ x 17 ⅝" (38 x 44.8 cm); sheet: 18 ¾ x 24 ¹³/₁₆" (47.7 x 63 cm). Publisher: unpublished. Printer: the artist at Atelier 17, New York. Edition: proof before the posthumous 1967 edition of 50. Gift of Lee Krasner Pollock, 1969. (Plate 40)

LYUBOV POPOVA
(Russian, 1889–1924)
Untitled from *Six Prints*. c. 1917–19. Linoleum cut with watercolor and gouache additions from a portfolio of six linoleum cuts with watercolor and gouache additions, one with oil additions, composition: 13 ⁷/₁₆ x 10 ¹³/₁₆" (34.1 x 27.5 cm); sheet: 15 ¼ x 11 ¹³/₁₆" (38.8 x 30 cm). Publisher: unpublished. Printer: the artist. Edition: 2 known sets. General Print

Fund, Edgar Wachenheim III Fund, and Harvey S. Shipley Miller Fund and by exchange: Nina and Gordon Bunshaft Bequest and Gift of Victor S. Riesenfeld, 2007. (Plate 4)

Untitled from *Six Prints*. c. 1917–19. Linoleum cut with watercolor and gouache additions from a portfolio of six linoleum cuts with watercolor and gouache additions, one with oil additions, composition: 13 ⁷/₁₆ x 10 ¹³/₁₆" (34.1 x 27.5 cm); sheet: 15 ¼ x 11 ¹³/₁₆" (38.8 x 30 cm). Publisher: unpublished. Printer: the artist. Edition: 2 known sets. General Print Fund, Edgar Wachenheim III Fund, and Harvey S. Shipley Miller Fund and by exchange: Nina and Gordon Bunshaft Bequest and Gift of Victor S. Riesenfeld, 2007. (Plate 5)

Untitled from *Six Prints*. c. 1917–19. Linoleum cut with watercolor and gouache additions from a portfolio of six linoleum cuts with watercolor and gouache additions, one with oil additions, composition: 13 ⁷/₁₆ x 10 ¹³/₁₆" (34.1 x 27.5 cm); sheet: 15 ¼ x 11 ¹³/₁₆" (38.8 x 30 cm). Publisher: unpublished. Printer: the artist. Edition: 2 known sets. General Print Fund, Edgar Wachenheim III Fund, and Harvey S. Shipley Miller Fund and by exchange: Nina and Gordon Bunshaft Bequest and Gift of Victor S. Riesenfeld, 2007. (Plate 6)

Untitled from *Six Prints*. c. 1917–19. Linoleum cut with watercolor and gouache additions from a portfolio of six linoleum cuts with watercolor and gouache additions, one with oil additions, composition: 13 ⁷/₁₆ x 10 ¹³/₁₆" (34.1 x 27.5 cm); sheet: 15 ¼ x 11 ¹³/₁₆" (38.8 x 30 cm). Publisher: unpublished. Printer: the artist. Edition: 2 known sets. General Print Fund, Edgar Wachenheim III Fund, and Harvey S. Shipley Miller Fund and by exchange: Nina and Gordon Bunshaft Bequest and Gift of Victor S. Riesenfeld, 2007. (Plate 7)

JOSÉ-GUADALUPE POSADA
(Mexican, 1852–1913)
Calavera de los Patinadores (Calavera of the street-cleaners). 1910. Type-metal engraving, relief printed, and letterpress, composition: 14 ³/₁₆ x 10 ¹/₁₆" (36 x 25.5 cm); sheet: 15 ¹¹/₁₆ x 11 ⅞" (39.9 x 30.1 cm). Publisher and printer: Antonio Vanegas Arroyo, Mexico City. Edition: unknown (unlimited). Inter-American Fund, 1965. (Plate 15)

ROBERT RAUSCHENBERG
(American, 1925–2008)
Surface Series 54 from *Currents*. 1970. One from a

portfolio of eighteen screenprints, composition: 35 ¹/₁₆ x 35 ¹/₁₆" (89 x 89 cm); sheet: 40 x 40" (101.6 x 101.6 cm). Publisher: Dayton's Gallery 12, Minneapolis, and Castelli Graphics, New York. Printer: Styria Studios, Glendale, Calif. Edition: 100. Gift of the artist, 2008. (Plate 111)

ODILON REDON
(French, 1840–1916)
Araignée (Spider). 1887. Lithograph, composition: 11 x 8 ⁹/₁₆" (28 x 21.7 cm); sheet: 20 ⅞ x 15 ¼" (53 x 38.7 cm). Publisher: the artist, Paris. Printer: Lemercier et Cie., Paris. Edition: proof outside the edition of 25. Mrs. Bertram Smith Fund, 1956. (Plate 64)

GERHARD RICHTER
(German, born 1932)
Flugzeug II (Airplane II). 1966. Screenprint, composition: 19 ⅛ x 32 ¹/₁₆" (48.6 x 81.4 cm); sheet: 24 x 33 ⅞" (61 x 86 cm). Publisher: Galerie Rottloff, Karlsruhe, Germany. Printer: Löw Siebdruck, Stuttgart, Germany. Edition: 20. Ann and Lee Fensterstock Fund, Alexandra Herzan Fund, and Virginia Cowles Schroth Fund, 1998. (Plate 102)

BRIDGET RILEY
(British, born 1931)
Untitled (Based on Movement in Squares). 1962. Screenprint, composition: 11 ⁷/₁₆ x 11 ⁵/₁₆" (29 x 28.7 cm); sheet: 20 ½ x 20 ½" (52 x 52 cm). Publisher: the artist, London. Printer: unknown. Edition: 26. Abby Aldrich Rockefeller Fund, 1964. (Plate 95)

DIEGO RIVERA
(Mexican, 1886–1957)
Autoretrato (Self-portrait). 1930. Lithograph, composition: 15 ⅞ x 11 ¼" (40.3 x 28.6 cm); sheet: 24 ⅞ x 18 ⅞" (63.2 x 47.9 cm). Publisher: Weyhe Gallery, New York. Printer: unknown, Mexico City. Edition: 100. Gift of Abby Aldrich Rockefeller, 1940. (Plate 73)

DIETER ROTH
(Swiss, born Germany. 1930–1998)
Berlin 1 from *Deutsche Städte* (German cities). 1970. One from a series of five screenprint over lithographs, composition: 22 ⅝ x 31 ½" (57.5 x 80 cm); sheet: 23 ⅝ x 33" (60 x 83.8 cm). Publisher: Edition Tangente, Heidelberg, Germany. Printer: Staib & Mayer (lithography) and Karl Löw (screenprint), Stuttgart, Germany. Edition: 100. Patricia P. Irgens Larsen Foundation Fund, 2008. (Plate 108)

Berlin 2 from *Deutsche Städte* (German cities). 1970. One from a series of five screenprint over lithographs, composition: 22 ⅝ x 31 ½" (57.5 x 80 cm); sheet: 23 ⅝ x 33" (60 x 83.8 cm). Publisher: Edition Tangente, Heidelberg, Germany. Printer: Staib & Mayer (lithography) and Karl Löw (screenprint), Stuttgart, Germany. Edition: 100. Patricia P. Irgens Larsen Foundation Fund, 2008. (Plate 109)

CHRISTOPH RUCKHÄBERLE
(German, born 1972)
Untitled (Woman 4). 2006. Linoleum cut on three sheets, composition: 37 ¾ x 78 ⅞" (95.9 x 200.3 cm); sheet (each): 39 ⅜ x 26 ¾" (100 x 67.9 cm). Publisher: the artist, Leipzig. Printer: Edition Carpe Plumbum, Leipzig. Edition: 20. Fund for the Twenty-First Century, 2007. (Plate 33)

EDWARD RUSCHA
(American, born 1937)
Standard Station. 1966. Screenprint, composition: 19 ⅝ x 36 ¹⁵⁄₁₆" (49.6 x 93.8 cm); sheet: 25 ⅝ x 39 ¹⁵⁄₁₆" (65.1 x 101.5 cm). Publisher: Audrey Sabol, Villanova, Pa. Printer: Art Krebs Screen Studio, Los Angeles. Edition: 50. John B. Turner Fund, 1968. (Plate 98)

Cheese Mold Standard with Olive. 1969. Screenprint, composition: 19 ⅝ x 36 ¹⁵⁄₁₆" (49.6 x 93.8 cm); sheet: 25 ⅝ x 39 ¹⁵⁄₁₆" (65.1 x 101.5 cm). Publisher: the artist, Los Angeles. Printer: Jean Milant and Daniel Socha at the artist's studio, Los Angeles. Edition: 150. Gift of the Associates of the Department of Prints and Illustrated Books in celebration of the Museum's reopening, 2004. (Plate 100)

Nine Swimming Pools from Book Covers. 1970. One from a series of six lithographs, composition: 8 ⁷⁄₁₆ x 11 ⁷⁄₁₆" (21.5 x 29 cm); sheet: 16 ⅛ x 20 ³⁄₁₆" (41 x 51.2 cm). Publisher and printer: Graphicstudio, University of South Florida, Tampa. Edition: 30. John M. Shapiro Fund, 2004. (Plate 81)

Twentysix Gasoline Stations from Book Covers. 1970. One from a series of six lithographs, composition: 8 ⁷⁄₁₆ x 11 ⁷⁄₁₆" (21.5 x 29 cm); sheet: 16 ⅛ x 20 ³⁄₁₆" (41 x 51.2 cm). Publisher and printer: Graphicstudio, University of South Florida, Tampa. Edition: 30. John M. Shapiro Fund, 2004. (Plate 80)

EDWARD RUSCHA
(American, born 1937)
with **MASON WILLIAMS**
(American, born 1938)
Double Standard. 1969. Screenprint, composition: 19 ⅝ x 36 ¹⁵⁄₁₆" (49.6 x 93.8 cm); sheet: 25 ⅝ x 39 ¹⁵⁄₁₆" (65.1 x 101.5 cm). Publisher: the artist, Los Angeles. Printer: Jean Milant and Daniel Socha at the artist's studio, Los Angeles. Edition: 40. Gift of the Associates of the Department of Prints and Illustrated Books in celebration of the Museum's reopening, 2004. (Plate 99)

SEHER SHAH
(Pakistani, born 1975)
Untitled from *The Black Star*. 2007. One from a portfolio of twelve digital prints, composition: 11 x 19" (27.9 x 48.2 cm); sheet: 16 ¹⁵⁄₁₆ x 21 ⅞" (43 x 55.5 cm). Publisher and printer: the artist, Brooklyn, N.Y. Edition: 10. Fund for the Twenty-First Century, 2008. (Plate 128)

Untitled from *The Black Star*. 2007. One from a portfolio of twelve digital prints, composition: 11 x 19" (27.9 x 48.2 cm); sheet: 16 ¹⁵⁄₁₆ x 21 ⅞" (43 x 55.5 cm). Publisher and printer: the artist, Brooklyn, N.Y. Edition: 10. Fund for the Twenty-First Century, 2008. (Plate 129)

JAMES SIENA
(American, born 1957)
Upside Down Devil Variation. 2004. Engraving, plate: 19 x 14 ¹⁵⁄₁₆" (48.2 x 37.9 cm); sheet: 26 ⅝ x 22 ¼" (67.6 x 56.5 cm). Publisher and printer: Harlan & Weaver, New York. Edition: 42. Gift of the Young Print Collectors of The Museum of Modern Art, 2004. (Plate 50)

LORNA SIMPSON
(American, born 1960)
Wigs (Portfolio). 1994. Portfolio of twenty-one lithographs on felt, with seventeen lithographed text panels on felt, overall: 6' x 13' 6" (182.9 x 411.5 cm). Publisher: Rhona Hoffman Gallery, Chicago. Printer: 21 Steps, Albuquerque, N.Mex. Edition: 15. Purchased with funds given by Agnes Gund, Howard B. Johnson, and Emily Fisher Landau, 1995. (Plate 88)

KIKI SMITH
(American, born Germany 1954)
White Mammals. 1998. Etching on seven sheets, plate (each): 32 x 18" (81.3 x 45.7 cm); sheet (each): 31 ⅜ x 22 ½" (79.7 x 57.2 cm). Publisher: Thirteen Moons, New York. Printer: Harlan & Weaver, New York. Edition: 14. Gift of The Junior Associates of The Museum of Modern Art, 1999. (Plate 51)

JOSÉ ANTONIO SUÁREZ LONDOÑO
(Colombian, born 1955)
Untitled #199. 2002. Etching, plate: 4 ⅝ x 4 ⅝" (11.8 x 11.8 cm); sheet: 11 x 7 ½" (28 x 19 cm). Publisher and printer: the artist, Medellín, Colombia. Edition: 3–5. Gift of the artist through the Latin American and Caribbean Fund, 2009. (Plate 54)

TABAIMO
(Japanese, born 1975)
show through II. 2009. Lithograph with monofilament in wooden frame, 36 ½ x 46 ½ x 1 ¾" (92.7 x 118.1 x 4.4 cm). Publisher and printer: Singapore Tyler Print Institute, Singapore. Edition: 8. Fund for the Twenty-First Century, 2010. (Plate 90)

ATSUKO TANAKA
(Japanese, 1932–2005)
Untitled from *for 1954*. 2005. Etching and aquatint from a portfolio of five etchings, one with aquatint, plate: 7 ¹¹⁄₁₆ x 5 ¾" (19.6 x 14.6 cm); sheet: 12 ⅝ x 9 ¹³⁄₁₆" (32 x 25 cm). Publisher: Gallery Ham, Nagoya, Japan. Printer: Junichi Goto, Nagoya, Japan. Edition: 20. Harvey S. Shipley Miller Fund, 2009. (Plate 55)

Untitled from *for 1954*. 2005. Etching from a portfolio of five etchings, one with aquatint, plate: 7 ¹¹⁄₁₆ x 5 ¾" (19.6 x 14.6 cm); sheet: 12 ⅝ x 9 ¹³⁄₁₆" (32 x 25 cm). Publisher: Gallery Ham, Nagoya, Japan. Printer: Junichi Goto, Nagoya, Japan. Edition: 20. Harvey S. Shipley Miller Fund, 2009. (Plate 56)

GERT & UWE TOBIAS
(both German, born Romania 1973)
Untitled (figure). 2005. Woodcut, sheet: 78 ¾ x 64 ¹⁵⁄₁₆" (200 x 164.9 cm). Publisher and printer: the artists, Cologne. Edition: 2. Fund for the Twenty-First Century, 2006. (Plate 32)

HENRI DE TOULOUSE-LAUTREC
(French, 1864–1901)
Miss Loïe Fuller. 1893. Lithograph, composition: 14 ⅜ x 10 ⅝" (36.5 x 27 cm); sheet: 14 ¹⁵⁄₁₆ x 11 ⅛" (38 x 28.2 cm). Publisher: André Marty, Paris. Printer: Edward Ancourt, Paris. Edition: approx. 60, each unique. General Print Fund, 2006. (Plate 66)

SUZANNE VALADON
(French, 1865–1938)
Marie au tub s'epongant (Marie bathing with a sponge). 1908. Drypoint, plate: 6 ⁹⁄₁₆ x 8 ⅝" (16.7 x 21.8 cm); sheet: 6 ¹¹⁄₁₆ x 8 ¾" (17 x 22.1

cm). Publisher and printer: probably the artist, Paris. Edition: proof before the 1932 edition of 75. Abby Aldrich Rockefeller Fund, 1949. (Plate 37)

KARA WALKER
(American, born 1969)
An Unpeopled Land in Uncharted Waters. 2010. Set of six etching and aquatints, plate (each): 10 ⅝–23 ⅞ x 35 ⅝" (27–60.6 x 90.5 cm); sheet (each): 30 ¼ x 11 ⅞–40 ¾" (76.8 x 30.2–103.5 cm). Publisher: Sikkema Jenkins & Co., New York. Printer: Burnet Editions, New York. Edition: 30. Committee on Prints and Illustrated Books Fund, 2010. (Plate 63)

KELLEY WALKER
(American, born 1969)
Beogram 4000 Hi Fi System. 2002. Digital print with CD-ROM, composition and sheet: 20 ⅜ x 29 ³⁄₁₆" (51.7 x 74.2 cm). Publisher and printer: the artist, New York. Edition: 5. Anna Marie and Robert F. Shapiro Fund, 2005. (Plate 125)

ANDY WARHOL
(American, 1928–1987)
Untitled from *Marilyn Monroe (Marilyn)*. 1967. One from a portfolio of ten screenprints, composition and sheet: 36 x 36" (91.5 x 91.5 cm). Publisher: Factory Additions, New York. Printer: Aetna Silkscreen Products, Inc., New York. Edition: 250. Gift of Mr. David Whitney, 1968. (Plate 103)

Untitled from *Marilyn Monroe (Marilyn)*. 1967. One from a portfolio of ten screenprints, composition and sheet: 36 x 36" (91.5 x 91.5 cm). Publisher: Factory Additions, New York. Printer: Aetna Silkscreen Products, Inc., New York. Edition: 250. Gift of Mr. David Whitney, 1968. (Plate 104)

Untitled from *Marilyn Monroe (Marilyn)*. 1967. One from a portfolio of ten screenprints, composition and sheet: 36 x 36" (91.5 x 91.5 cm). Publisher: Factory Additions, New York. Printer: Aetna Silkscreen Products, Inc., New York. Edition: 250. Gift of Mr. David Whitney, 1968. (Plate 105)

Untitled from *Marilyn Monroe (Marilyn)*. 1967. One from a portfolio of ten screenprints, composition and sheet: 36 x 36" (91.5 x 91.5 cm). Publisher: Factory Additions, New York. Printer: Aetna Silkscreen Products, Inc., New York. Edition: 250. Gift of Mr. David Whitney, 1968. (Plate 106)

CHARLES WHITE
(American, 1918–1979)
Solid as a Rock (My God is Rock). 1958. Linoleum cut, composition: 38 ³⁄₁₆ x 14 ¹⁵⁄₁₆" (97 x 38 cm); sheet: 41 ⅛ x 17 ¹³⁄₁₆" (104.5 x 45.2 cm). Publisher: unpublished. Printer: the artist. Edition: 3 known examples. John B. Turner Fund with additional support from Linda Barth Goldstein and Stephen F. Dull, 2010. (Plate 23)

HANNAH WILKE
(American, 1940–1993)
Marxism and Art: Beware of Fascist Feminism. 1977. Screenprint on Plexiglas, composition and sheet : 35 ⁷⁄₁₆ x 27 ⅜" (90 x 69.5 cm). Publisher: the artist. Printer: unknown. Edition: unique (25 planned). General Print Fund, Riva Castleman Endowment Fund, Harvey S. Shipley Miller Fund, The Contemporary Arts Council of The Museum of Modern Art, and partial gift of Marsie, Emanuelle, Damon, and Andrew Scharlatt, Hannah Wilke Collection and Archive, Los Angeles, 2008. (Plate 113)

FRED WILSON
(American, born 1954)
Arise! 2004. Aquatint and etching, plate: 19 ⅞ x 23 ⅞" (50.5 x 60.6 cm); sheet: 30 ¾ x 33 ¾" (78.1 x 85.7 cm). Publisher and printer: Crown Point Press, San Francisco. Edition: 25. John B. Turner Fund, 2005. (Plate 57)

TERRY WINTERS
(American, born 1949)
Factors of Increase. 1983. Lithograph, composition: 31 ⅜ x 17 ½" (79.7 x 44.5 cm); sheet: 31 ⅜ x 23 ¾" (79.7 x 60.3 cm). Publisher and printer: Universal Limited Art Editions, West Islip, N.Y. Edition: 30. Gift of Celeste Bartos, 1983. (Plate 87)

WOLS
(Alfred Otto Wolfgang Schulze; German, 1913–1951)
Plate 1 from *Naturelles* by René de Solier. 1946. One from an illustrated book with four drypoints, plate: 5 ⅜ x 3 ½" (13.7 x 8.9 cm); sheet: 6 ⅜ x 4 ¹⁵⁄₁₆" (16.2 x 12.5 cm). Publisher: the artist and the author, Paris. Printer: the artist, Paris. Edition: proof before the published edition of 50. Gift of Victor S. Riesenfeld, 1948. (Plate 43)

Plate 2 from *Naturelles* by René de Solier. 1946. One from an illustrated book with four drypoints, plate: 4 ¹³⁄₁₆ x 3 ⅞" (12.2 x 9.9 cm);

sheet: 6 ⅜ x 4 ¹⁵⁄₁₆" (16.2 x 12.5 cm). Publisher: the artist and the author, Paris. Printer: the artist, Paris. Edition: proof before the published edition of 50. Gift of Victor S. Riesenfeld, 1948. (Plate 44)

XU BING
(Chinese, born 1955)
Yi-yun (Moving cloud) from Series of Repetitions. 1987. One from a series of ten woodcuts, composition: 20 ½ x 28 ⅜" (52 x 72 cm); sheet: 26 x 35 ¹³⁄₁₆" (66 x 91 cm). Publisher and printer: the artist, Beijing. Edition: 50. Riva Castleman Endowment Fund, 2010. (Plate 25)

YUKINORI YANAGI
(Japanese, born 1959)
Untitled from *Wandering Position*. 1997. One from a portfolio of five etchings, plate: 18 x 15 ¹³⁄₁₆" (45.7 x 40.2 cm); sheet: 24 ¹⁄₁₆ x 20 ¹⁄₁₆" (61 x 50.9 cm). Publisher: Peter Blum Edition, New York. Printer: Harlan & Weaver, New York. Edition: 35. Frances Keech Fund, 1997. (Plate 49)

SELECTED BIBLIOGRAPHY

Antreasian, Garo Z., and Clinton Adams. *The Tamarind Book of Lithography: Art & Techniques.* Los Angeles: Tamarind Lithography Workshop, Inc., 1971.

Benson, Richard. *The Printed Picture.* New York: The Museum of Modern Art, 2008.

Brown, Kathan. *Ink, Paper, Metal, Wood: How to Recognize Contemporary Artists' Prints.* San Francisco: Crown Point Press, 1992.

Brunner, Felix. *A Handbook of Graphic Reproduction Techniques.* Teufen, Switzerland: A. Niggli, 1962.

Castleman, Riva. *Modern Art in Prints.* New York: The Museum of Modern Art, 1976.

———. *Modern Artists as Illustrators/Artistas modernos como ilustradores.* New York: The Museum of Modern Art, 1981.

———. *Prints from Blocks.* New York: The Museum of Modern Art, 1983.

———. *American Impressions: Prints Since Pollock.* New York: A. A. Knopf, 1985.

———. *A Century of Artists Books.* New York: The Museum of Modern Art, 1994.

Coldwell, Paul. *Printmaking: A Contemporary Perspective.* London: Black Dog Publishing, 2010.

Didi-Huberman, Georges. *L'Empreinte.* Paris: Centre Georges Pompidou, 1997.

D'Oench, Ellen G. *Block, Plate, Stone: What A Print Is.* Contribution by Susan Salzberg Rubin. Katonah, N.Y.: Katonah Museum of Art, 1994.

Drucker, Johanna. *The Century of Artists' Books.* New York: Granary Books, 1995.

Eichenberg, Fritz. *Lithography and Silkscreen: Art and Technique.* New York: Harry N. Abrams, 1978.

Faine, Brad. *The Complete Guide to Screenprinting.* Cincinnati: North Light Books, 1989.

Gabrowski, Beth, and Bill Fick. *Printmaking: A Complete Guide to Materials and Process.* London: Lawrence King, 2009.

Gascoigne, Bamber. *How to Identify Prints.* New York: Thames and Hudson, 1986.

Gilmour, Pat. *Modern Prints.* London: Studio Vista, 1970.

———. *The Mechanised Image: An Historical Perspective on 20th Century Prints.* London: Arts Council of Great Britain, 1978.

———. *Understanding Prints: A Contemporary Guide.* London: Waddington Galleries, 1979.

———. *Artists in Print: An Introduction to Prints and Printmaking.* London: British Broadcasting Corporation, 1981.

———. *Lasting Impressions: Lithography as Art.* Philadelphia: University of Pennsylvania Press, 1988.

Griffiths, Antony. *Prints and Printmaking: An Introduction to the History and Techniques.* Berkeley: University of California Press, 1996.

Hayter, Stanley William. *New Ways of Gravure: Innovative Techniques of Printmaking Taken from the Studio of a Master Craftsman.* New York: Watson-Guptill, 1981.

Heller, Jules. *Printmaking Today: An Introduction to the Graphic Arts.* New York: Holt, 1958.

Henning, Roni. *Screenprinting: Water-Based Techniques.* New York: Watson-Guptill, 1994.

Hults, Linda C. *The Print in the Western World: An Introductory History.* Madison: University of Wisconsin Press, 1996.

Lambert, Susan. *Prints: Art and Techniques.* London: V&A Publications, 2001.

Lo Monaco, Louis. *La Gravure en taille-douce: Art, histoire, technique.* Paris: Arts et métiers graphiques/Flammarion, 1992.

Nadeau, Luis. *Encyclopedia of Printing, Photographic, and Photomechanical Processes: A Comprehensive Reference to Reproduction Technologies.* Fredericton, N.B., Canada: Atelier Luis Nadeau, 1989.

Platzker, David, and Elizabeth Wyckoff. *Hard Pressed: 600 Years of Prints and Process.* New York: Hudson Hills Press, 2000.

Porzio, Domenico, ed. *Lithography: 200 Years of Art, History & Technique.* New York: Harry N. Abrams, 1983.

Romano, Claire, John Ross, and Tim Ross. *The Complete Printmaker: Techniques, Traditions, Innovations.* New York: Free Press, 1990.

Sachs, Paul J. *Modern Prints & Drawings: A Guide to a Better Understanding of Modern Draughtsmanship.* New York: Knopf, 1954.

Sacilotto, Deli. *Photographic Printmaking Techniques.* New York: Watson-Guptill, 1982.

Saff, Donald, and Deli Sacilotto. *Screenprinting: History and Process.* New York: Holt, Rinehart and Winston, 1979.

———. *Printmaking: History and Process.* London: British Broadcasting Corporation, 1981.

Sperling, Louise, and Richard S. Field. *Offset Lithography.* Middletown, Conn.: Davidson Art Center, Wesleyan University, 1973.

Weber, Wilhelm. *A History of Lithography.* New York: McGraw-Hill, 1966.

Wye, Deborah. *Thinking Print: Books to Billboards, 1980–1995.* New York: The Museum of Modern Art, 1996.

———. *Artists & Prints: Masterworks from The Museum of Modern Art.* New York: The Museum of Modern Art, 2004.

PHOTO CREDITS

Individual works of art appearing herein may be protected by copyright in the United States of America, or elsewhere, and may not be reproduced in any form without the permission of the rights holders. In reproducing the images contained in this publication, the Museum obtained the permission of the rights holders whenever possible. Should the Museum have been unable to locate the rights holders, notwithstanding good-faith efforts, it requests that any contact information concerning such rights be forwarded, so that they may be contacted for future editions.

© 2011 The Josef and Anni Albers Foundation/Artists Rights Society (ARS), New York: plates 18, 93, 94.

© 2011 Estate of Sybil Andrews: plate 12.

© 2011 Cory Arcangel: plate 118.

© 2011 Artists Rights Society (ARS), New York/ADAGP, Paris: plates 37, 43, 44, 68, 78.

© 2011 Artists Rights Society (ARS), New York/DACS, London: plate 96.

© 2011 Artists Rights Society (ARS), New York/SABAM, Brussels: plates 35, 107.

© 2011 Artists Rights Society (ARS), New York/VG Bild-Kunst, Bonn: pages 12, 13; plates 10, 11, 28, 29, 34, 67.

© 2011 Georg Baselitz: plate 22.

© 2011 Thomas Bayrle/Artists Rights Society (ARS), New York/VG Bild-Kunst, Bonn: plate 101.

© 2011 Ashley Bickerton: plate 114.

© 2011 Louise Bourgeois Trust: plate 45.

© 2011 Cai Guo-Qiang: plate 127.

© 2011 Ernesto Caivano: plates 52, 53.

© 2011 Paul Chan: plates 130, 131.

© 2011 Chuck Close: plate 31.

© 2011 Willie Cole: plate 126.

© Estate of Stuart Davis/Licensed by VAGA, New York: plate 69.

© 2011 The Willem de Kooning Foundation/Artists Rights Society (ARS), New York: plate 77.

© 2011 Eugenio Dittborn: plate 112.

© 2011 León Ferrari: plate 121.

© Estate of Claude Flight: plate 13.

© 2011 Estate of Sam Francis/Artists Rights Society (ARS), New York: plate 76.

© 2011 Helen Frankenthaler/Artists Rights Society (ARS), New York: plate 24.

© 2011 Lucian Freud: plate 48.

© 2011 Ellen Gallagher and Two Palms Press: plate 132.

© 2011 Fundación Gego: plate 47.

© 2011 Robert Gober: plate 89.

© 2011 The Estate of Philip Guston: plate 84.

© 2011 Peter Halley: plate 115.

© 2011 David Hammons: plate 122.

© 2011 Zarina Hashmi: plate 27.

© 2011 Erich Heckel/Artists Rights Society (ARS), New York/VG Bild-Kunst, Bonn: plate 8.

© David Hockney/Tyler Graphics Ltd.: plate 82.

© 2011 Ryoji Ito: plates 55, 56.

© Jasper Johns/Licensed by VAGA, New York: plates 75, 110.

© Judd Foundation/Licensed by VAGA, New York: plates 20, 21.

© 2011 Ellsworth Kelly: plate 79.

© 2011 Yayoi Kusama: plate 46.

© 2011 Sherrie Levine: plate 26.

© Estate of Roy Lichtenstein: plate 97.

© 2011 Glenn Ligon: plates 85, 86.

© 2011 Estate of John Marin/Artists Rights Society (ARS), New York: plate 38.

© 2011 Barry McGee: plates 61, 62.

© 2011 Ryan McGinness: plate 116.

© 2011 Lucy McKenzie: plate 30.

© 2011 Julie Mehretu: plate 59.

© 2011 Joel Méndez: plate 14.

© 2011 Successió Miró/Artists Rights Society (ARS), New York/ADAGP, Paris: plates 41, 42.

© 2011 Sarah Morris: plate 119.

© 2011 The Munch Museum/The Munch-Ellingsen Group/Artists Rights Society (ARS), New York: plates 3, 65.

© 2011 Elizabeth Murray: plate 83.

Courtesy The Museum of Modern Art, New York, Department of Imaging Services. Photos: plates 14, 38, 65, 67, 69, 73, 77, 92, 105–107. Photos: David Allison: plates 102, 111. Photos: Kelly Benjamin: plates 2, 17–19, 40, 93, 94. Photos: Peter Butler: pages 12, 13; plates 20, 45, 50, 77, 82, 87, 108, 109, 123, 124, 128, 129. Photos: Robert Gerhardt: plates 8–11, 34, 39, 80, 81, 122. Photos: Thomas Griesel: plates 13, 21, 23, 26, 27, 31, 55–58, 74, 75, 96, 100, 101, 103, 111, 112, 114, 116, 118, 119, 127. Photos: Kate Keller: plates 1, 24, 79, 97, 110. Photos: Paige Knight: plate 51. Photos: Erik Landsberg: plate 46. Photos: Jonathan Muzikar: plates 12, 25, 30, 36, 43, 44, 48, 49, 63, 66, 70–72, 90, 104, 117, 121, 126. Photos Mali Olatunji: plate 98. Photos: John Wronn: plates 3–8, 22, 28, 29, 32, 33, 35, 37, 41, 42, 47, 52–54, 60–62, 64, 68, 75, 76, 83–86, 88, 91, 99, 113, 115, 120, 125, 130–132.

© 2011 Paul Noble: plate 120.

© Nolde Stiftung Seebüll, Germany: plates 9, 39.

© 2011 Shaun O'Dell: plate 58.

© 2011 Julian Opie: pages 114, 115; plate 117.

© 2011 Projeto Lygia Pape: plate 19.

© 2011 Dan Perjovschi: plates 123, 124.

© 2011 Elizabeth Peyton: plate 60.

© 2011 Estate of Pablo Picasso/Artists Rights Society (ARS), New York: plates 16, 36, 70–72.

© 2011 Pollock-Krasner Foundation/Artists Rights Society (ARS), New York: plate 40.

© Estate of Robert Rauschenberg/Licensed by VAGA, New York: plate 111.

© 2011 Gerhard Richter: plate 102.

© Bridget Riley 2011. All rights reserved, courtesy Karsten Schubert, London: plate 95.

© 2011 Banco de México Diego Rivera Frida Kahlo Museums Trust, Mexico, D.F./Artists Rights Society (ARS), New York: plate 73.

© 2011 Estate of Dieter Roth: plates 108, 109.

© 2011 Christoph Ruckhäberle: plate 33.

© 2011 Edward Ruscha: plates 80, 81, 98–100.

© 2011 José Sanchez/Artists Rights Society (ARS), New York/VEGAP, Spain: plate 17.

© 2011 Seher Shah: plates 128, 129.

© 2011 James Siena: plate 50.

© 2011 Lorna Simpson: plate 88.

© 2011 Kiki Smith: plate 51.

© 2011 José Antonio Suárez Londoño: pages 48, 49; plate 54.

© 2011 Tabaimo: plate 90.

© 2011 Gert and Uwe Tobias: plate 32.

© 2011 Kara Walker: plate 63.

© 2011 Kelley Walker: plate 125.

© 2011 Andy Warhol Foundation for the Visual Arts/Artists Rights Society (ARS), New York: plates 103–106.

© 2011 Marsie, Emanuelle, Damon and Andrew Scharlatt, Hannah Wilke Collection and Archive, Los Angeles: plate 113.

© 2011 Fred Wilson: plate 57.

© 2011 Terry Winters: pages 82, 83; plate 87.

© 2011 Xu Bing: plate 25.

© 2011 Yukinori Yanagi: plate 49.